ANGLESEY AT WORK

GERAINT WYN HUGHES

AMBERLEY

First published 2023

Amberley Publishing
The Hill, Stroud
Gloucestershire, GL5 4EP

www.amberley-books.com

Copyright © Geraint Wyn Hughes, 2023

The right of Geraint Wyn Hughes to be identified as the
Author of this work has been asserted in accordance
with the Copyrights, Designs and Patents Act 1988.

ISBN 978 1 4456 9984 4 (print)
ISBN 978 1 4456 9985 1 (ebook)

British Library Cataloguing in Publication Data.
A catalogue record for this book is available
from the British Library.

Typesetting by SJmagic DESIGN SERVICES, India.
Printed in the UK.

CONTENTS

INTRODUCTION

The low-lying island of Anglesey, with an area of 290 square miles and extending 23 miles from north-west to south-east and 21 miles from north-east to south-west, is separated from the mountainous Welsh mainland by the Menai Strait. Its varied geological foundation spans Precambrian to Permo-Triassic rocks that provide a high geodiversity that unavoidably influenced the original biodiversity although the latter has, to variable extents, been destroyed or negatively modified by work activities. Unlike other titles in this series that are city or town based, the pastoral aspects of the low-lying landscape of Anglesey combined with the extensive and highly indented coastline have resulted in work activities biased towards those related to natural resources of the subsurface, land and sea and less to those associated with manufacture or heavy industry. This text, therefore, is focussed on work related to agriculture, fishing, shipping, mining, large and small industries and services. Also included are the variety of activities that have influenced these foundations of Anglesey work, of which the magnificent Telford's Menai Bridge and Stephenson's Britannia Bridge are the most famous.

Man has been at work on Anglesey since the Mesolithic period, around 7000 BC. Results of man's work from this period can still be clearly seen in the numerous stone burial chambers and hill forts. Neolithic times and more sophisticated agriculture resulted in cleared woodlands, crop cultivation and communities living in circular stone houses. Over fifty stone burial buildings are preserved, and artifacts indicate a reasonable degree of trade, especially in pottery, stone tools, arrowheads and stone axes. Metallic implements, decorated stones and imported ornaments mark the start of the Bronze Age, from 2500 to 1500 BC, indicating trade for Cornish tin. Celts with more resistant iron tools arrived around 500 BC and increased agricultural efficiency and fortified hill settlements. Roman occupation of Anglesey at AD 60 and at AD 77/78 until around AD 430 continued the trend of fortification and agriculture to supply the garrisons at Caergybi (Holyhead) and Segontium (Caernarfon) as well as copper working. Roman occupation would have attracted the attentions of merchants offering every sort of service including alehouses, bakeries, tailors, cobblers, smiths and other tradesmen.

By the end of the early Middle Ages, the variety of current major work activities related to the sea, land and underground was well established. With increased industry by the

mid-1800s work diversification was intense, as seen at Amlwch which had three drug shops, eight butchers, thirteen tailors, eleven carpenters, three watch and clock makers, six selling china, one printer, four bookshops, six ironmongers, three ship repairers, four tea and coffee houses, three sailmakers, one blockmaker, eight shoemakers, twelve coal merchants, five flour merchants, three candlemakers, twenty drapers, twenty-six grocers, one savings bank, one post office and one custom house. Tourism is now the major economic activity on the island, with agriculture providing the secondary source of income, mostly from the dairy industry.

AGRICULTURE

The varied geology, physical land features, soil types and climate have all influenced agricultural activities in Anglesey, and the widespread distribution of farms testifies to a high proportion of the population involved in this work. The erosional platform of the island has led to a subdued topography that has favoured intensive agricultural development; in turn, this has sadly transformed Anglesey into a 96 per cent tree-cleared, grassland-dominated landscape. The cover of glacially derived sediments has tended to mask the contrasting soils that would otherwise have been derived from the highly variable geology of which the latter has had a more profound impact on drainage. Anglesey weather is milder than that on the mainland, with its oceanic climate and relatively small seasonal variations in temperature, occasional snowfall and hard frosts, rainfall of between 750 mm and 1,000 mm and prevailing south-westerly winds. The elm decline of 5210 BC, detected by palynology at Cors Goch and elsewhere in Britain, has been attributed to Neolithic farming, followed by further deforestation by the Celts and Romans. Absence of good-quality pasture has, until recent years, limited the availability of year-round forage for feeding cattle, which is now solved using silage. Cereals and livestock were mostly farmed on a subsistence basis, with the crops more suited for stock feeding than for sale.

Agricultural fairs were already common in the thirteenth century, with Llanfaes being the chief commercial centre of Anglesey in the early Middle Ages. It was destroyed following Madoc's revolt in 1294 and the occupants forcibly moved to Newborough. Beaumaris and Newborough became the centres of fairs, in addition to those at Aberffraw and Llannerch-y-medd in 1346, and these centres persisted until the seventeenth century. Newborough was the leading cattle market in North Wales but declined after the great sandstorm of 1331. Porthaethwy held fairs by 1683 and at the same time Llannerch-y-medd had six fairs a year, two of which were horse fairs, with five fairs in Newborough and four each at Beaumaris, Porthaethwy and Aberffraw. Fairs increased in their distribution and number but by 1918 they had decreased to Llangefni, Llannerch-y-medd, Menai Bridge, Tŷ-Croes, Bodorgan and Valley.

The Anglesey diet, from pre-Christian Celts to the sixteenth century, was probably centred on dairy, bread and oat porridge. Potatoes were introduced in the late 1600s and were favoured over grains because they were easy to grow and required less work than oats or dairy. This trend led to an unhealthy reliance on a single starchy crop, especially in 1846 when the fungus *Phytophthora infestans* caused failure of the potato crop. Those living

by the sea could, at least, supplement their diet with fish. Cheap imports of grain in the late nineteenth century forced the farmers to turn to stock-rearing, prior to which Anglesey was the granary of Wales, producing more than 90,000 bushels of barley and oats in 1770. Anglesey's present economy derives from tourism, with agriculture second, although its historic dominance is expressed in the following poem:

> *Pan ydoedd newyn gynt mewn gwlad*
> *Ac angen yno'n ffynnu*
> *Nid ydoedd raid ond troi I Fôn*
> *Yn union rhag newynu*
> *Pa ryfedd oedd ym more son*
> *Ei galw'n Fôn Mam Cymru*

> When there was famine in the land
> And when need thrived
> All that was needed was to turn to Môn
> As not to starve
> No wonder in the early days
> To call her Môn Mam Cymru

CATTLE

Anglesey's mild climate and landscape, in general, favours dairy production. Although dairy cattle are kept all over the island, their greatest concentrations are seen in the north-west, between Llanfechell and the southern part of the Alaw catchment area, and the central south-eastern flank of the island south of the Malltraeth depression. Milk production on Anglesey was, until 1944, channelled through the creamery at Bangor until its capacity was exceeded and a new 3,965-gallon-capacity Milk Marketing Board (MMB) creamery opened in Llangefni. The milk was sent from Llangefni to Gaerwen and then by train to Liverpool. In 1950 at least 1,000 farms supplied Llangefni and around fifty supplied dairymen locally, from over 2,500 holdings with at least one cow. In 1954 the site was sold to Cadbury's but repurchased by the MMB in 1961. The creamery was relaunched as Glanbia Cheese Ltd in 1992. The dairy industry in Anglesey, as with Wales in general, has been influenced by global price competition and skilled labour shortage. The low-cost and high-forage, grass-based, spring block-calving dairy system of New Zealand is being increasingly adopted and raises concerns over animal welfare, loss of hedgerows and wildlife protection. The attraction of increased profitability has led to grazing expansion and destruction of remaining natural meadows that were supporting wildlife. Cheesemaking is an important dairy product and, in addition to large processing companies, artisan cheesemaking is increasingly popular, such as the award-winning Anglesey Blue (Mon Las) at Rhyd y Delyn Farm at Pentraeth.

Welsh Black cattle are the native breed of Wales and have lived in the Welsh hills since Roman times. Being used as an early currency led to them being called the 'black gold of the Welsh hills'. Their hardy nature enables them to thrive in the harsh weather and poor grazing conditions to produce excellent milk, butter, cheese and beef. They also occasionally acted as a draft animal. The Welsh Black Cattle Society state that traditional Welsh homesteaders did not keep the Welsh Black cow, but the Welsh Black cow kept them! Their resistance to the harsh weather is due to their '*cot a wasgod*', meaning a coat of long outer windproof hairs and waistcoat of

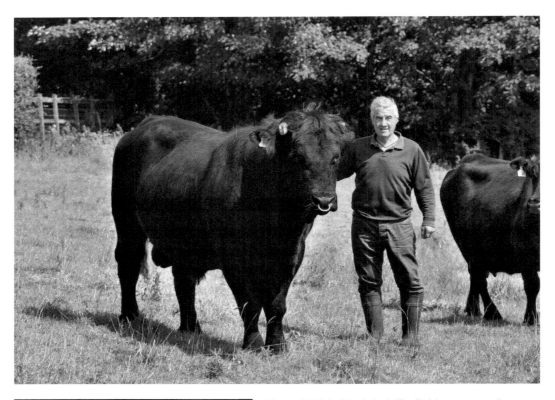

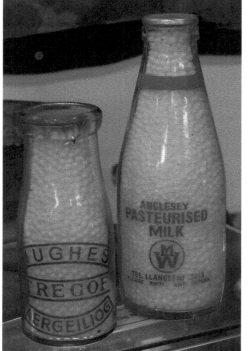

Above: Welsh Black bull Tryfil Maximus with owner Mr David Farrell.

Left: Milk bottles from past private dairies in Caergeiliog and Llangefni. (Courtesy of D. Wilson, Stone Science)

short inner, waterproof and insulating hairs. The modern Welsh Black was developed in 1904 by crossing the beefier Anglesey type with the mainly dairy South Walian Castlemartin strain.

At Bryn Dyfrydog Farm a fine collection of over 150 cattle are kept on less intensive, wildlife-friendly land. The clear contentment and good nature of the cows and the six-year-old local bull Tryfil Maximus testify to the care of owners Mr and Mrs David Farrell. Welsh Blacks, sheep and pigs are kept by the Hooton family and sold at their shops at Brynsiencyn and Llanfairpwll. Many people are employed on the farm and the business has grown and diversified considerably from its potato and cereal origins in 1968.

THE DROVERS

The Welsh economy has historically benefitted greatly from the export of cattle and by the mid-seventeenth century store cattle exports were one of the primary sources of Welsh revenue. Drovers (*porthmyn*) were responsible for herding cattle, sheep or geese over long distances. There is tentative evidence of drover activity from Wales to Mercia across Offa's Dyke since the late eight century, but regular cattle movement from Wales to England was established in the thirteenth century and responsible for tracks known as the Welsh Road and Welsh Way. Tax records for 1292 list drovers from the Menai Commote of Anglesey and another record of 1538–44 describes drover Ric ap Kynneryke from Anglesey who sold forty-four oxen for £48-16-00 and 210 bullocks and barren cows for £115-10-00. The Welsh Black cattle were ideal for droving because of their calm temperament, tolerance of harsh Welsh weather and relief, ability to increase weight when they reached the richer English pastures and because they were in great demand in the southern England markets. Smithfield was the most popular destination and developed into the largest animal market in the world. The drovers were well respected, especially after the Tudor period when licensing became compulsory, and trust in their honesty led them to being carriers of money and books. Drovers would collect cattle from large and small farms and from local fairs, gradually increasing the size of the herd to typically 100 to 400 cattle attended by four to eight drovers and their corgi dogs for the three-week journey. Cow shoes, called 'cues', had to be fitted before the long walk.

Roman routes were often followed that became 40 feet to 90 feet wide to accommodate the large herds. Copper coins minted on Anglesey were used by drovers to pay for accommodation and animal feed. Elias (2018) illustrates two drovers' routes across Anglesey. One route was from Llanfachraeth to Porthaethwy, where they swam across the Strait to Bangor, and the second from Llannerch-y-medd to Beaumaris, where they swam across to the Lavan Sands.

In the 1640s the drovers carried Ship Money from Anglesey to the Treasury, leading to Archbishop John Williams of Bangor calling them the 'Spanish fleet of Wales' to ensure passage to England during the Civil War. Export of 3,000 cattle from Anglesey in 1638, over 10,000 in 1794 and 14,000 in 1810 indicate the importance of this trade. Drovers' influences are seen in English place names such as Welsh Road, Welshman's Hill, Welsh Meadow, Welsh Road Farm, Welsh Road Bridge, Welsh Road Gorse, Cow Cross, Bulls Bridge, Drift, London End, Llundain Fach, Llundain Fechan, Cowpool and Bodwel, the latter referring to cow manure! In the Welsh open countryside, farmers willing to provide food, accommodation and grazing would plant three Scots pines, and in England yews, so that they could be seen from a distance by the drovers. The Great Depression and cheap imports of Irish cattle caused a decline in drover activity in the late 1870s, and it ceased completely following the coming of the railway.

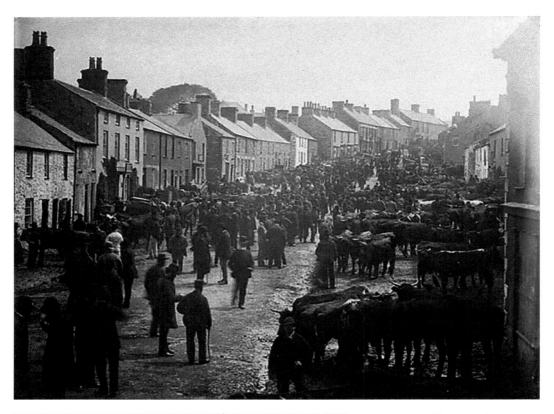

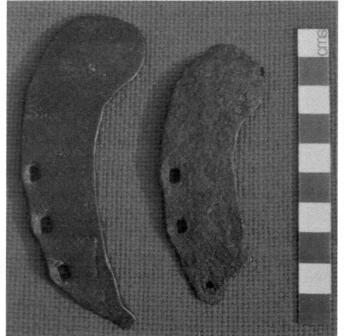

Above: Welsh Black cattle in the Llannerch-y-medd Fair, *c.* 1880.

Left: A pair of cow shoes collected from Llandegai. (Courtesy of Twm Elias)

SHEEP

Prior to the Second World War, pastoral farming dominated Anglesey with the production of fat cattle and fat lambs. In 1939 the area of land under crops was 11 per cent, with oats being the most important crop followed by turnips and potatoes. This was markedly increased to 34 per cent by 1943 by the 'ploughing up' campaign, resulting in a decrease of land for cattle and lambs of which dairy cattle had priority. The emphasis of sheep production on Anglesey is on the marketing of fat lambs in this year in which they were born, and this returned soon after the war and has been steadily increasing on the island. One of Anglesey's unique developments is that of EasyCareTM sheep. These sheep were developed by local farmer Iolo Owen in the early 1960s by crossing predominantly Wiltshire Horns with the Nelson type of Welsh Mountain sheep. Their dense fleece enables them to withstand harsh winter weather and they have a distinct advantage of shedding their fleece in summer and do not need shearing. Another innovation at a Bryngwran farm is the trial rearing of Damara sheep from the Middle East aimed to provide meat to consumers preferring the particularly fatty character of this species.

DOVES AND CHICKEN FARMING

Near Penmon Priory is a domed roof dovecote built around 1600 on the Bulkeley estate. Inside is a honeycomb of over 1,000 stone recesses that were used by the nesting doves and pigeons as a source of meat and eggs. A small cupola on the rooftop allowed the birds to fly in and out. These could be accessed from a 12-foot-high central pillar. It could be considered as a real 'free-range' forerunner of the chicken farms that are increasing on Anglesey. To feed the apparently insatiable demand for meat, Anglesey has, over the past twenty years, turned to intensive chicken rearing with at least 2.5 million chickens on the island at any one time.

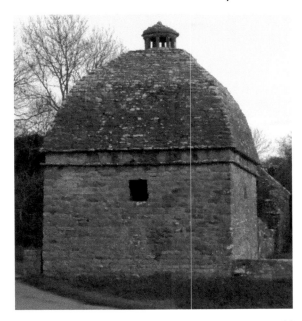

The dovecote at Penmon, designed to provide a constant source of pigeons.

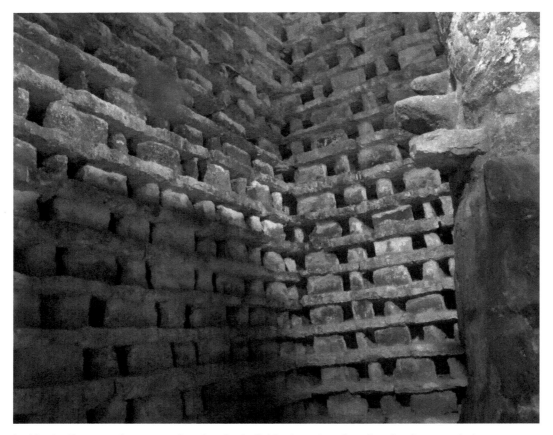

Inside the Penmon dovecote, showing the individual resting place for the doves and pigeons.

HORSES AND ALPACAS

Llannerch-y-medd was the traditional centre for horse and cattle trading. Fairs were also held at Llangefni and Porthaethwy, up to six times a year, although the central position of Llangefni gradually led to it becoming the dominant market in the early twentieth century. Today horses are not used on the land but are used for natural grazing of reserves and on several riding schools. Anglesey Alpacas have established a herd of forty alpacas since 2016, some of which are rescues or rehomed. The alpacas are kept for their fleece and as livestock and provide alpaca experiences and alpaca craft workshops. From their farm near Bethel they contribute to the local community being shown at care homes, schools and hospices.

OLIVES AND VINEYARDS

An olive grove has been established near Llanbadrig since 2007, using olives from a part of Italy that experiences frost and snow. It is currently the most northerly olive grove and vineyard in Europe, and possibly in the world. Vineyards also exist near Red Wharf Bay.

MILLS

WINDMILLS FOR GRAIN

Anglesey's fertile and low-lying land still produces a rich harvest of oats, barley and wheat. Hand-operated quern stones have been found in the 3,400-year-old Cytiau Gwyddelod on Holyhead Mountain and some of Roman age. Windmills, or *felin gwynt*, were common on

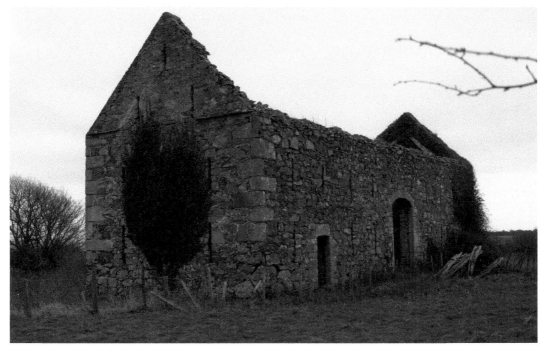

Henblas threshing barn in 2019. The barn has recently been carefully and tastefully renovated and now provides luxury holiday accommodation and is an event venue called The Tythe Barn at Henblas.

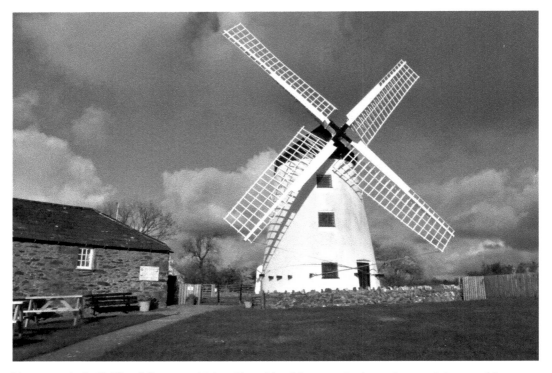

Llynnon windmill. The 9.3-metre-high mill, at Llanddeusant, is the only remaining working windmill in Wales and produces stoneground wholemeal flour using organic wheat. It is an agricultural museum and café offering home-made confectionary.

Anglesey since the Middle Ages but peaked during the eighteenth and nineteenth centuries when larger population and wars created a demand for flour. Of the original forty-nine windmills, the remains of thirty-one are still visible. The first windmill on Anglesey was Newborough, established on 28 June 1305. The most northerly windmill in Wales was Pant y Gaseg near Amlwch. Melin y Bont, Llanfaethlu, was the only wind- and water-driven mill in Wales. Llynnon Mill operated as a corn mill from 1776 but ceased operating in 1918. After storm damage in 1954 it was rescued by Anglesey Borough Council and has been the only Welsh working windmill since 11 May 1984 and is active today. Grain separation took place in threshing barns such as that at Henblas Farm, dated 1733, and at Cornelyn Manor. The threshing process took an hour for each bushel of wheat but was replaced by threshing machines in 1786.

WATERMILLS FOR GRAIN

Water mills, or *felin d☐r*, used water flow either directly or by a millpond of which ten are known and include Bodowyr (Llanidan), Esgob (Rhosybol), Trefarthen (Llanidan), Gronant (Llanfaethlu), Felin Gafnan (Cemlyn), Hen Felin (Pwll Fanog), Melin Hywel (Llanddeusant), Llywenan (Bodedern) and Melin y Bont (Llanfaelog). Melin Hywel, or Melyn Selar, with a 14-foot overshot wheel, has been on location since 1352 and is the best preserved. Water mills provided a less reliable source of power than the windmills.

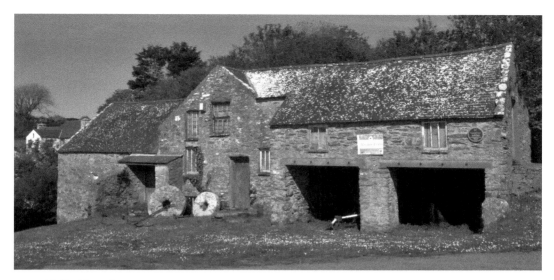

Melin Hywel.

TIDAL MILLS FOR GRAIN

Tidal movement of sea water for mechanical energy is a current topic but tidal mills, or *felin heli*, were used on Anglesey since the early sixteenth century, especially when wind and water power sources were low. Seven tidal mills are known on Anglesey and include the Melin Bodior and Tre'r Gof near Trearddur Bay, with the earliest at Tysilio Island. The mills were positioned on tidal inlets blocked by a dam breached at high tide. A sluice gate was raised at the falling tide and turned a wheel that then rotated the millstone. At

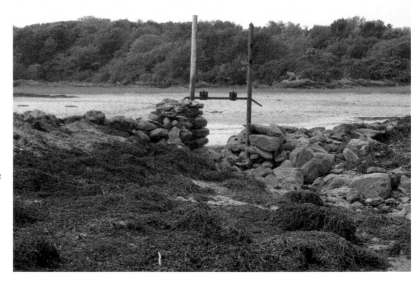

View looking landward to the dam and area occupied by the saltwater reservoir created during high tide.

Bodior, built in 1495 by Rhys ap Llywelyn ap Hwlcyn, the appropriately named Ty'n y Felyn is located on the hill above the dam. The lack of tracks at Bodior suggests that the corn was transported to the mill by boat. The last tidal mill to operate was Melin Wen at Llanfair Yn Neubwll in 1870. Great potential for rejuvenating the tidal mill concept lies at the Stanley Embankment where the sluice gate could be adapted for the generation of electricity.

GORSE MILLS

Gorse mills, or *felin eithin*, were used from the eighteenth century until the end of the Second World War as gorse was an important part of the workhorse diet. The gorse was grown on a large scale but had to be bruised or crushed to make it edible. Gorse-crushing mills were originally driven by a waterwheel but by 1850 were replaced by hand- or oil-powered smaller ones. Only one gorse mill remains, at Melin Fron near Llangefni, and is currently being refurbished by owner Dr Wyn Morgan. Here the wheel-powered millstones crushed gorse in the smaller building on the right.

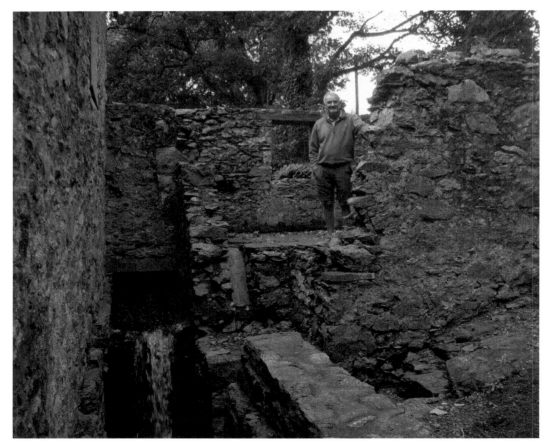

Melin Fron, the only surviving gorse mill on Anglesey and possibly Wales. (Courtesy of Dr W. Morgan)

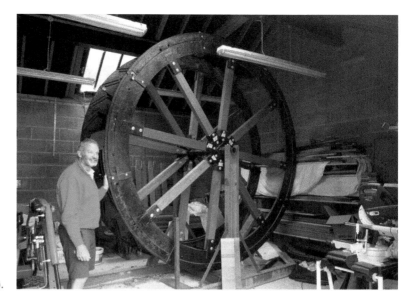

Dr W. Morgan refurbishing the original 10-foot-diameter waterwheel at Melin Fron, Llangefni (in 2020).

MILLSTONES

Anglesey millstones, *Maen melin Ynys Mon*, using local Carboniferous quartz-rich sandstones and conglomerates, were the best in Wales and were chiselled out in place. The three major millstone quarries were at Pen'rallt, near Brynteg, Cors Goch, near Llyn Cadarn and reputedly the best at Bwlchgwyn, near Benllech. Millstones were sold for 28s 9*d* in 1314 and were exported to the Baltic from Mathafarn quarry. Several unfinished millstones lie in the ground because of damage during extraction but some were left in the ground at the demise of the local industry due to cheaper ones from Paris (French Burr) and the Rhine Valley.

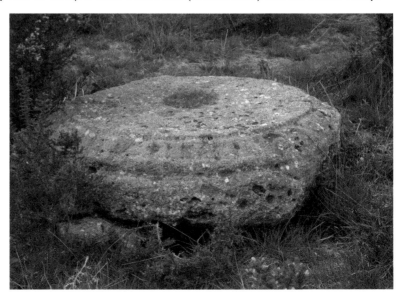

Unfinished millstone of Carboniferous quartz-rich 'millstone grit' at Cors Goch. This millstone was abandoned during its extraction and remains at the site of its manufacture.

WATERMILLS FOR WOOL

Sheep's wool was shorn twice yearly and would have been combed and dyed on the farms. Woollen mills were observed by Geraldus Cambrensis during his visit to Anglesey in 1188 but activity was centralised in 1430 with the first water-driven woollen and fulling mill at Llanfechell. Water-powered fulling mills produced an industrial revolution in Wales and were used to bind together the wool fibres in the thirteenth century but it was not until the sixteenth century that spinning and weaving became a serious industry in North Wales. The finer lowland wool of Anglesey was mixed with coarse wool of the Snowdonia Mountain sheep. The woollen mills on the island produced colourful blankets, rugs and flannel and 120 men were employed in the woollen mills of Anglesey in 1835. Numerous buildings named Pandy indicate a fulling mill, where human urine was used to strip the wool of dirt and oils, followed by felting using mill-driven wooden hammers to provide strength and waterproofing. The felted material was stretched on tenterhooks on tenter frames. Pandy Llywenan manufactured deep-red blankets characteristic of those made on Anglesey. Pandy Parc, on the Afon Goch, produced carpets and is an eighteenth-century former water-powered woollen factory as well as a fulling mill, each with a wheel. It was part of the Baron Hill estate in 1722, stopped operating in 1861 but restarted in 1871 by Manchester weavers. Pandy Parc is the best preserved water mill on the island and has benefitted from considerable renovation by its current owners, Mr and Mrs David Wagstaff. In 1870 woollen mills were working at Llanfechell, Cemaes, Llandyfrydog, Erw-goch, Llywenan, Llangefni and Cadnant with twenty-one fulling mills. By the early nineteenth century only eight of the original thirty-one mills remained, at Llanfechell (built in 1430), Cadnant (1605), Llangefni (1607), Cemaes (1698) Llywenan (1782), Erw Goch/ Alaw, Newborough, and Moelfre and provided blankets and clothing for the soldiers of both wars. Pandy Llywenan was the last mill to close in the mid-1950s.

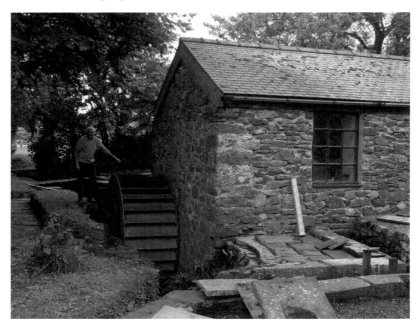

Current engineer owner of Pandy Parc Mr David Wagstaff, with the renovated wheel at the fulling building.

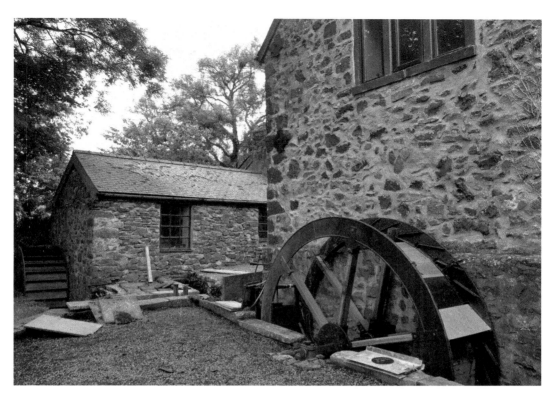

Above: Pandy Parc mill wheels. Fulling mill building in the distance and weaving room and mill wheel in the foreground.

Right: Mr Pritchard, weaver at the Pandy Parc loom, *c.* 1926. (Courtesy of Mr D. Wagstaff)

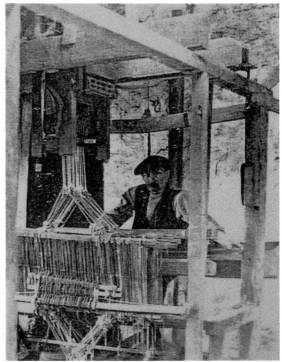

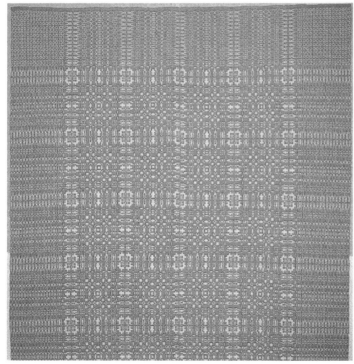

Above: Tenter frame, Pandy Parc, c. 1926. (Courtesy of Mr D. Wagstaff)

Left: Woollen bedspread, 168 cm x 215 cm, woven at Pandy Parc around 1890–1910, given to Oriel Môn by Mair Morris in 2010.

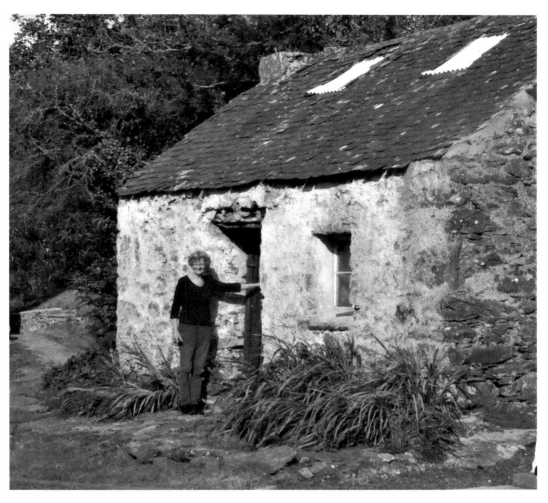

Above: Pandy Llywenan warping house with the owner, Mrs Sylvia Speers, daughter of the last operator of the mill.

Right: Pandy Llywenan tweed mill owner Mr Ernest Naish (left) and weavers. (Courtesy of Mrs Sylvia Speers)

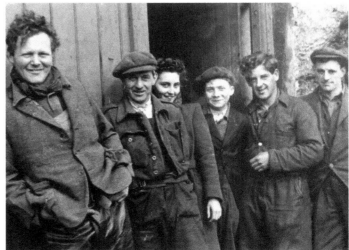

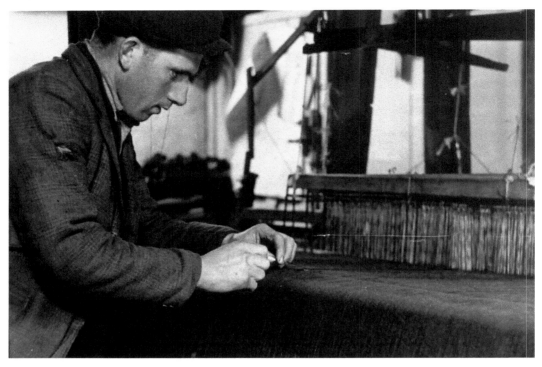

Pandy Llywenan weaver at work. (Courtesy of Mrs Sylvia Speers)

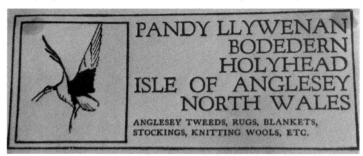

Pandy Llywenan letterhead. (Courtesy of Mrs Sylvia Speers)

Fabric from Pandy Llywenan. (Courtesy of Mrs Sylvia Speers)

W. M. Pritchard,

Woollen Manufacturer,

WYGYR FACTORY, CEMAES BAY,

ANGLESEY, N.W.

Patronised by Her Majesty the Queen.

Manufacturer of

Real Welsh Home-spun for Ladies' Costumes
of every description.

Also WHITE and COLOURED FLANNELS, BLANKETS,
CLOTH and SERGES. All made by Hand Looms.

WELSH and ENGLISH WOOLS kept in Stock, also
STOCKINGS.

Note.—THE ONLY MANUFACTURER OF WELSH HOME-SPUN IN THE DISTRICT.

All Orders receive best and prompt attention.

Pritchard's Wygyr Wool Factory advertisement, Cemaes Bay. (Courtesy of Mrs Carys Davies)

WINDMILLS FOR OTHER POWER

Industrial windmills are few on the island. The uniquely five-sailed Parys Mountain windmill was purchased in 1788 to reduce the cost and transport of coal to the steam engine used to pump water from the copper mine. It was still operating in 1901 but ceased when copper mining became uneconomical. Melin Tan Yr Efail at Holyhead was used to saw wood in 1914. At Amlwch a windmill was used to crush ochre from Parys for colours and paints at the St Elian Colour Works, using a pair of vertical edge stones. A water-powered sawmill, located on the harbour side of the building, was in operation in Amlwch in 1853 to provide the various shipbuilders with sawn timber.

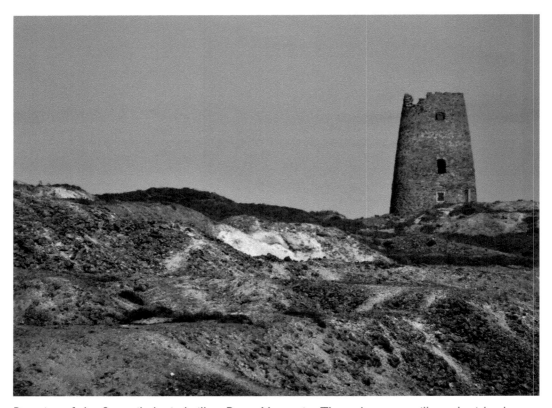

Remains of the five-sailed windmill at Parys Mountain. The only pump-mill on the island, it was used to drain the copper mines dry enough for the men to extract the copper ore under atrocious conditions.

MARITIME WORK

Anglesey's insular character has naturally provided varied sea-related work, primarily fishing – it is noteworthy that in the early nineteenth century, the two Welsh counties from where naval officers originated were Anglesey and Pembrokeshire. Cemaes sailor Thomas Jones was made famous and given the nickname Twm Titanic after he gallantly saved the lives of thirty-two *Titanic* passengers on his lifeboat 8. It is impossible to imagine that fishing was not an important way of procuring food on Anglesey since the island was occupied by man, evidenced by limpet shells in Bronze Age middens on Holy Island mountain and in Neolithic middens in the Newborough Forest. Many of the prehistoric sites are coastal and the few inhabitants would have been able to continue sustainable coastal fishing. The remains of medieval fish traps, 'gorad' in Welsh, are off Llanfaes, two off the Beaumaris foreshore and off Gallows Point. Gorad Goch and Gorad Ddu are in the Strait and another remains on the Alaw Estuary. Anglesey's fishing industry has declined markedly, due mostly to unsustainable fishing practices and destruction of ecosystems.

HERRING FISHING

Herring fishing lasted from October until February, using drift nets 30 feet long and 10 feet deep. It peaked in the sixteenth century with salted herring exported to Chester and Liverpool, but this ceased at the start of the Second World War. Frequent herring shoal failure increased dependence on agriculture, and potatoes were selected as a new crop around 1775. Moelfre herring was a much-sought commodity. The shallow Benllech Bay with its proximity to the railway was a preferred fish-landing site. Herring caught by boats from Scotland, Ireland and the Isle of Man landed their herring catches at Holyhead in the early twentieth century where Scottish women, termed 'herring lassies', would gut, salt and pack the fish into barrels prior to export to Europe by rail. Today there is a greater awareness of the frailty of the marine environment and the dangers of overfishing by local and foreign vessels.

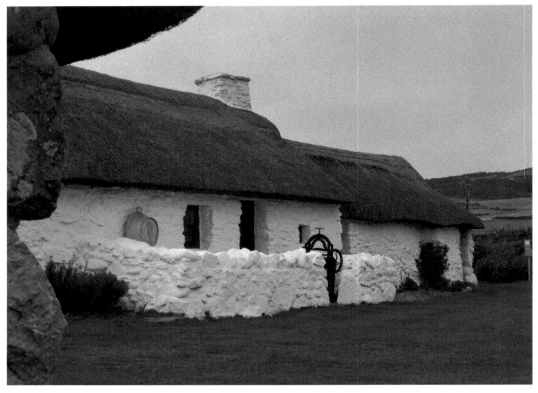

Fisherman's cottage at Porth Swtan.

FISH FARMING

Despite Dinmor Quarry lying in an Area of Outstanding Natural Beauty and a Site of Scientific Interest, it nevertheless became a turbot farm in July 2001 employing eight people. Later, a halibut farm funded by the Welsh European Funding Office commenced production in 2009 but later farmed sea bass. Pollution and financial difficulties led to take over by Anglesey Aquaculture Ltd, producing 12 tonnes of sea bass a week and employing twenty-six local people. It succeeded by its premium quality and freshness compared with cheaper imported Mediterranean fish but eventually closed due to even cheaper imported fish. In 2017, the world's largest salmon farm, Marine Harvest, now Mowi, saved the Penmon site with a plan to produce the 'cleaner fish' wrasse as a natural alternative to chemical lice-inhibitors, freshwater baths and mechanical removal on salmon farms.

SHELLFISH

Mussels, king and queen scallops, oysters, lobsters, shrimps, brown crab and whelks support a successful shellfish industry. Since 1600, the lobsters of Rhosneigr have been popular and became a natural alternative for the fishermen when the herring shoals became depleted. In the twentieth century, an annual catch of 400 lobsters was regarded as average from twenty

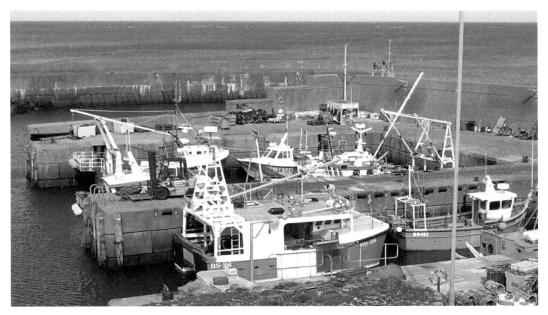

Amlwch harbour still provides shelter for local fishing boats.

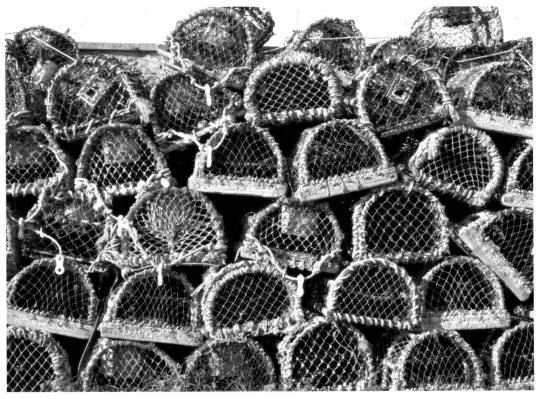

Lobster pots at the Tal y Foel ferry.

pots a day, although this could never be considered sustainable. The Cefni Estuary and the shallow seas around Llanddwyn Island have historically provided cockles for local collection. Shellfish are currently collected and exported by five companies based on Holy Island, Church Bay, Bull Bay and Dwyran, including the well-known Lobster Pot and Menai Mussels companies. Mussels and oysters thrive on the nutrient-rich waters of the Menai Strait.

WHALING

It is shameful that such a practice as whale hunting ever existed, and even more that is exists today as a 'Japanese research project'. Nevertheless, as one-third of the Anglesey workforce was unemployed in 1936, whaling was an unexpected work opportunity. Unilever, owners of the Southern Whaling and Sealing Company, decided to recruit British crew for their factory ships. Twenty-four men from Holyhead, ten from Amlwch and two each from Cemaes and Moelfre sailed on the *Southern Princess* and *Southern Empress* in October 1936 and returned from the Antarctic in the spring of 1937 after killing 1,422 whales. A further expedition over the 1938 and 1939 winters employed ninety and one hundred Anglesey men respectively.

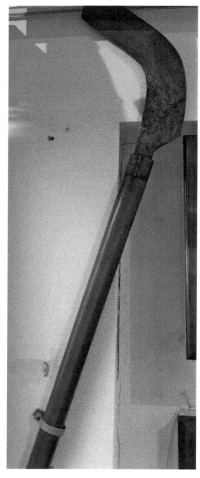

A flensing knife used by the Anglesey whalers.
(Courtesy of the Holyhead Maritime Museum)

LIGHTHOUSES AND OTHER NAVIGATION AIDS

The rugged coastline of Anglesey is served by eight lighthouses including South Stack, Holyhead Breakwater, Holyhead Salt Island, The Skerries, Amlwch, Port Lynas, Trwyn Du (Penmon) and Llanddwyn, of which that on the Skerries was the first to be built in 1730. Robustly constructed, they were built of local stone and supported the local quarrying industry. All lighthouses are now remotely controlled and, with seventeen buoys and two beacons, are visited twice a year from the Trinity House maintenance centre in Swansea. At North Stack is the redundant fog warning station where warning to passing ships was provided by cannon fire, a bell and, in 1895, by an oil-powered reed fog siren.

On Carmel Head are two large concrete triangular structures that align with a similar structure on West Mouse island. These are the Coal Rock Beacons, also known locally as the White Ladies, or Two Sisters, and were erected by the Mersey Docks and Harbour Board in the 1860s to aid navigation of sailing ships along this extremely dangerous rocky coastline.

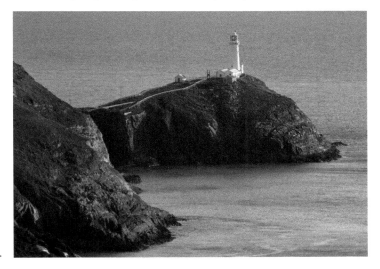

South Stack Lighthouse.

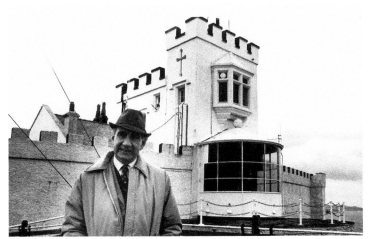

Mr David Rothwell Herbert, the last residential manager of the Point Lynas Lighthouse.

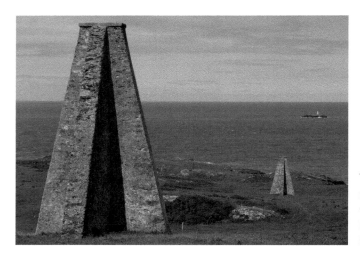

The White Ladies navigation markers on Carmel Head with West Mouse island in the background.

LIFEBOATS

Anglesey's rocky and exposed north coastline is the site of many shipwrecks, with 550 wrecks recorded between 1808 and 1914. The first lifeboat on Anglesey was stationed below Llanfairynghornwy rectory in Cemlyn Bay and coxwained by Revd and Mrs Williams. They formed the Anglesey Lifeboat Association in 1828 which became a branch of the Royal National Lifeboat Institute in 1857. In 1849, six of the nineteen lifeboats stationed around Britain were based on Anglesey, indicating the local need for such important support. Now, the RNLI has stations at Holyhead, Trearddur Bay, Moelfre and Beaumaris and can reach casualties up to 50 miles offshore.

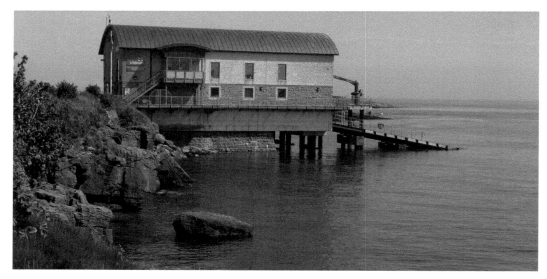

Moelfre Lifeboat Station. The calm conditions in this photograph belie the horrific stormy conditions that have caused many shipwrecks and fatalities of which the *Royal Charter* is the most infamous with the loss of 411 lives.

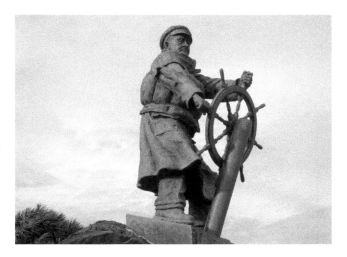

Bronze statue of Coxswain Richard Evans (1905–2001) outside Moelfre RNLI. He was awarded the RNLI golden medal for his brave rescue of the eight crew of the Hindlea on the lifeboat *Edmund and Mary Robinson* during a 100-mph gale on 27 October 1959.

The *Royal Charter* ship, with a large quantity of gold, was wrecked at Moelfre en route from Melbourne to Liverpool on 25 October 1859. Exactly 100 years later the *Moelfre* lifeboat heroically saved the crew of the *Hindlea* which suffered a similar fate.

DULAS ISLAND REFUGE TOWER

A most unusual cylindrical stone tower with a cone-shaped top, 9 metres high, was built on Dulas Island, approximately 1 mile offshore in Dulas Bay, in 1821 by Colonel James Hughes. It was a landmark for sailing ships, many of which were wrecked on the island. It provided shelter, water and food until rescue was available.

Dulas Bay refuge tower.

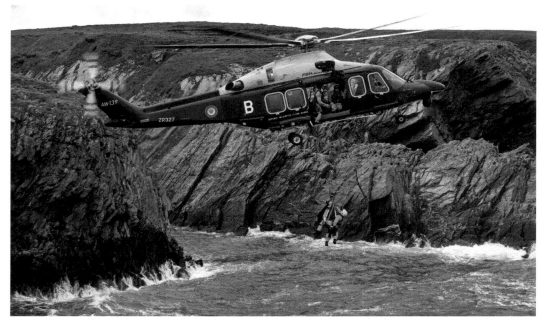

Search and Rescue Training Unit (SARTU) Augusta Westland AW139 helicopter from RAF Valley on a training exercise on the Anglesey coast. (Courtesy of the National Archives, Open Government Licence)

RAF SEARCH AND RESCUE

The RAF station at Valley provides helicopter support for coastal rescue around Anglesey and the region. It is home to Squadron 202 RAF, and both RAF and Royal Navy pilots transitioning from Basic Flying to fast jets are also trained here. It serves as a command and control centre for three Valley-based RAF teams as well as those at Lossiemouth and Leeming. It is home to Squadron 220 RAF, which has operated search and rescue missions for over fifty years. The station trains both RAF and Royal Navy pilots. RAF Valley is also home to the Mountain Rescue Service, the military's only high readiness, all weather search and rescue aircraft post-crash management asset. 1,500 service personnel, civil servants and contractors work at RAF Valley. RAF Mona provides a landing field for the Valley Flying Training School operating the Hawk T2 aircraft. Since 2019, RAF Valley has trained RAF and Royal Navy pilots on newly delivered Texan T6C advanced turboprops.

COASTGUARD SERVICE

HM Coastguard is the national maritime 999 service for search and rescue of beach, coast and sea users in distress and provides a national twenty-four-hour maritime and coastal search and rescue (SAR) emergency response service throughout the UK. Anglesey coastguard centres are located at Holyhead, Cemaes, Moelfre, Penmon and Rhosneigr and provide a vital support service to ensure marine safety around the Anglesey coast.

Above: Amlwch coastguard tower on top of the coastguard cottages, built in 1877 but closed in 1927.

Right: The coastguard store at Holyhead harbour with vehicle in old livery (2018).

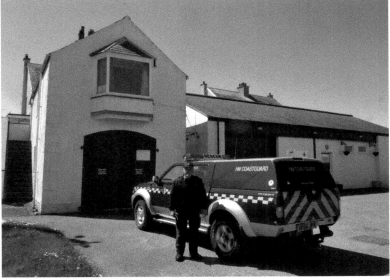

Above: Coastguard station near Rhoscolyn, ensuring the safety of sailors off the west coast of Holy Island.

Left: Vintage semaphore lamp used by the Cemaes coastguard service. (Courtesy of Mrs Carys Davies)

Fulmar Gwyn and Turnstone pilot boats moored at Anglesey.

PILOT SERVICE

Until 1650, coastal shipping from Ireland was directed to the port of Chester until the 1740s when Liverpool became the busiest slave trade port in Europe. Before 1766 local pilots would cruise west of the Skerries in search of ships to guide through the treacherous Mersey sand bars. In the eighteenth century Mersey pilots had a watch-house on the Llaneilian headland with a light consisting of a candle and two reflectors. After the 1766 Act, the Liverpool Pilot Service was formalised and pilots were compelled to operate four pilot boats between Priestholm (Puffin Island) and Point Lynas. Pilots were stationed at Point Lynas from 1 October 1781. The pilot boats were moored at Point Lynas until a storm in 2015 destroyed the boarding gantry. Although the crews on the pilot boats are all Anglesey men, pilots travel from Liverpool whenever required.

SHIPYARDS

Shipbuilding was centred at Holyhead, Beaumaris and Amlwch, with smaller centres at Cemaes, Red Wharf Bay, Dulas Bay and Moel y Don and even smaller works at Pwllfanogl, Malltraeth, Aberffraw, Llanfaelog, Llanfachreth, Bull Bay and Moelfre. Those at Holyhead, Beaumaris and Amlwch built ships between 50 and 100 tons including brigs, brigantines, sloops and schooners, mostly constructed from wood from Canada and the Baltic. The

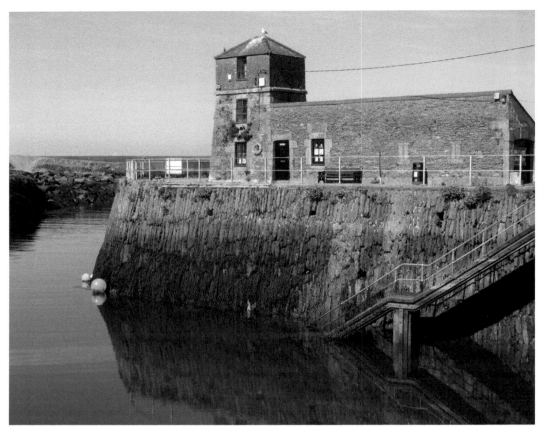

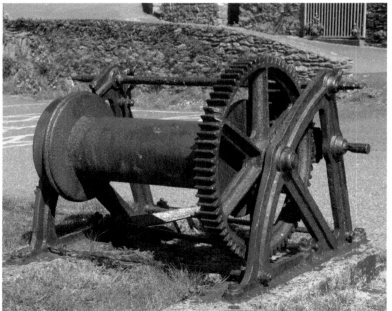

Above: The entrance to the shipbuilding centre of Amlwch harbour.

Left: Winch on Amlwch harbour used to haul timber baulks that were placed across the harbour mouth to protect the moored sailing ships during times of northerly gales.

entrance to the shipbuilding centre of Amlwch harbour, guarded by the watch-house and lighthouse, was built in 1853. Nicholas Treweek, from Cornwall, established a yard employing thirty-two men when he was commissioned by his father, James, to build a 68-ton sloop called *Unity* in 1825. Red Wharf was a shipbuilding centre during the eighteenth and nineteenth centuries. Ishmael Jones was a famous shipbuilder at Cemaes, where he employed sixty men above Traeth Sincio, with workshops that are now cottages. The invention of steamships in the mid-nineteenth century led to a sharp decline in the wooden shipbuilding industry of Anglesey.

SAILMAKING

To support the sailing ships being built at Amlwch harbour, sails were made and repaired at the sail loft there, dating from around 1870. Its sloping floor assisted in the sewing process, using Manchester-manufactured Perkins sewing machines. The sail loft is now part of the Copper Kingdom heritage complex.

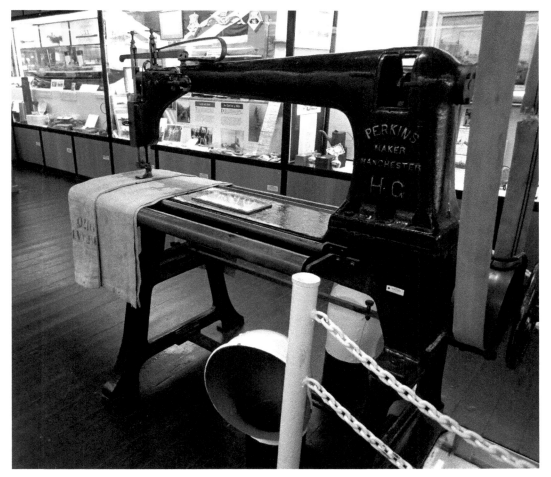

Sail-sewing machine used in Amlwch harbour. (Courtesy of the Holyhead Maritime Museum)

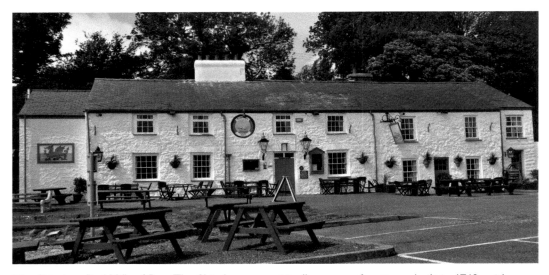

The Ship Inn, Red Wharf Bay. The Ship Inn was originally a row of cottages built in 1740, with a small pub within the cottage on the left. The pub has been known as Cei Bach (Little Quay), Arwydd y Llong (The Sign of the Ship) and Quay Inn until the early twentieth century when it became the Ship Inn. Although the port was small, it was busy and attracted ships with cargo from all over the world. Skilled sailors were required to navigate the shallow waters and rapid tide changes, and guide large vessels to the end of the bay, which provided natural shelter. The main commodity imported was coal and the main commodity exported was limestone. (Traeth Coch)

COASTAL TRADE

Anglesey is a natural seafaring island and between 1740 and 1840 enjoyed coastal trade from Beaumaris, Amlwch and Holyhead to Hull, Dublin, Drogheda, Dundalk, Newry, Belfast, Liverpool, London, Carlisle and Berwick on Tweed. Coastal trade mostly involved the transport of limestone from Moelfre, Morfa Bychan, Red Wharf Bay and Penmon, and copper ore from Amlwch. Beaumaris handled much of the Caernarfonshire slates and shipped them to Liverpool, London, Hull, Scotland and Ireland. Limestone and sand were exported from Red Wharf Bay to the growing city of Liverpool. Coal was transported from Malltraeth to Amlwch, but later imported in greater volumes from the mainland coalfields to Amlwch and Red Wharf Bay. The new Menai Bridge brought trade to Porthaethwy, and the need for warehouses. Richard Davies of Llangefni built a warehouse in the late 1840s, renovated by Menter Môn and Menai Heritage, and owned eleven ships for transatlantic and transpacific trade. He imported North American timber for his sawmill and exported slate, as well as transporting Anglesey and Caernarfonshire emigrants to America. One old storehouse, built in 1751, remains on the seafront at Red Wharf Bay, next to the Ship Inn, but trading ceased on the arrival of the railway in 1909.

MARINE TRAINING

Royal and Merchant Navy officer training took place on the Mersey in a succession of three ships, each named *Conway*. The *Conway* was moored off Glyn Garth, Llandegfan, on 22 May

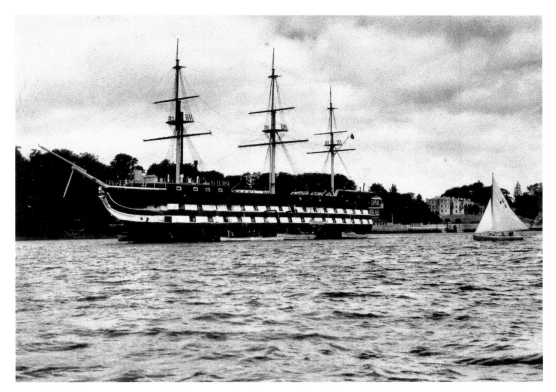

HMS *Conway* moored offshore its land base at Plas Newydd. (Courtesy of Mr A. Windsor)

1941, to avoid bomb damage. This location had been occupied from 1877 to 1921 by the reform ship *Clio*. In 1947, Plas Newydd was selected as a shore base to where it was towed on 12 April 1949 through water described by Nelson as 'one of the most treacherous stretches of sea in the world'. By 1953 the ship needed a refit and towing to Merseyside commenced at 08.22 on 14 April 1953 but by around 10.30 she had come aground on Platters Rocks on the south side of the Strait, and was declared a total loss on 16 April. A replacement nautical college building named the Conway Centre was opened at Plas Newydd 6 May 1964 but was closed on 11 July 1974. The centre is now a residential arts and outdoor education facility. TS *Indefatigable* trained boys for life at sea as deck crew and was originally moored next to HMS *Conway* in the Mersey until 1941 when it transferred to Anglesey as a land-based training centre.

QUARRYING AND MINING

Anglesey's Palaeozoic geological legacy has endowed it with several resources of economic value. Their exploitation since the Bronze Age has depended on the work skills of geologists, mineralogists, engineers, miners, explosive experts, builders, jewellers as well as requiring support from various services including toolmakers, doctors, grocers, shoemakers, innkeepers and tobacconists. The hard igneous and metamorphic rocks of Precambrian and Cambrian Age have provided a source of building stone and road metal. Pure white quartzite has been used for resistive engineering projects such as the Holyhead Breakwater as well as for supporting a refractory brick industry. Kaolinite, derived from the weathering of igneous rocks, has been exported for the ceramic industry. Some pillow lavas contain the semi-precious mineral jasper used for jewellery and ornaments. Copper, from the Lower Palaeozoic rocks, represents the primary mineral for which Anglesey was once the world's greatest supplier. Associated with the copper was the varicoloured pigment ochre. Of the Carboniferous sedimentary rocks, the quartz-rich conglomerates have provided millstones and the limestones have been used to build houses, bridges and large buildings on and outside the island. Limited coal resources have been exploited for local use.

BUILDING STONES

Precambrian metamorphic rocks and granite is extracted from several quarries, of which probably the largest is that owned by Hanson Concrete at Coedana. Granite is a rather

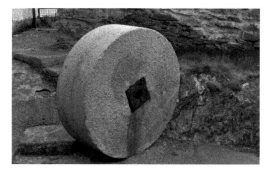

Millstone used vertically for crushing rock, now lying near Point Lynas Lighthouse. Local millstone expert Richard Williams considers that it was probably located at the Pengorffwysfa quarry. Such rock-grinding millstones were made from very hard igneous rocks, not the quartz grits used to crush grain.

loose term used for resistant rocks for use as aggregates, asphalt and concrete that can be used as road metal as well as in the building and construction industries. There are remains of small quarries at many locations where hard rocks are exposed. The largest quarry currently active is the Caer Glaw Quarry at Gwalchmai. The granite is crushed and processed to form ready-mix concrete.

LIMESTONE

Carboniferous limestone is exposed at several locations in eastern Anglesey and has been used as a building stone since at least 3000 BC, as seen at the Lligwy Burial Chamber. The oldest limestone quarries are those at Penmon and Benllech from where stone was extracted to build the castles of Aberlleiniog, Beaumaris and Caernarfon. Moelfre limestone has been used to construct most of the major buildings on Anglesey, especially the Menai bridges as well as Birmingham Town Hall. This industry provided work for Anglesey men and over 200 were employed in the Red Wharf quarries alone in 1833. Liverpool's building demand for limestone and 'marble', between 1821 and 1835, led to much work in White Lady's Bay quarry, Cemaes, and an increase in the local population by 400.

Crushed local limestone was roasted and slaked in the limekilns, such as this one at Traeth Bychan.

The Norman castle at Aberlleiniog was originally built in 1088 on a motte-and-bailey site.

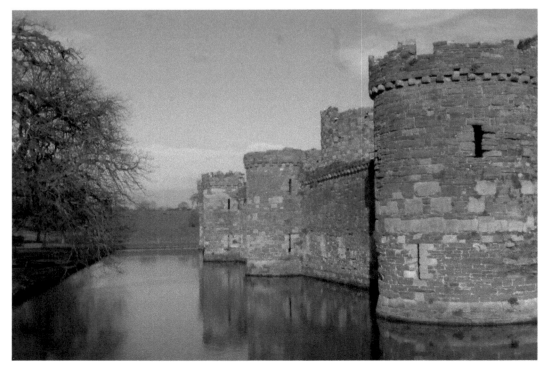

Beaumaris Castle was constructed of limestone blocks from Dinmor quarry. Although building commenced in 1295 it remained unfinished in the 1320s.

SILICA

Shining rocky white cliffs form much of the north flank of Holy Island, and this almost pure source of silica has been exploited on Holyhead Mountain from the geological formation known as the Holyhead Quartzite. This Lower Cambrian resistant rock was used to create the breakwater protecting Holyhead harbour. The 1.8-mile breakwater was constructed between 1847 and 1873 and was not only a mammoth project but led to the excavation of a mammoth jawbone that is displayed in the Holyhead Maritime Museum.

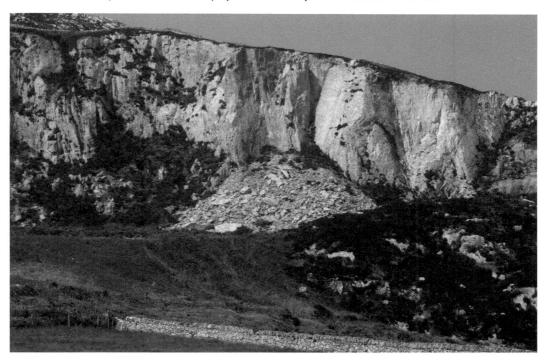

Above: White cliffs of Holyhead Quartzite at Holyhead Mountain.

Right: One of two explosive stores for the Holyhead quarry. This one on Holyhead Mountain also stored gunpowder for the fog-warning cannon at North Stack.

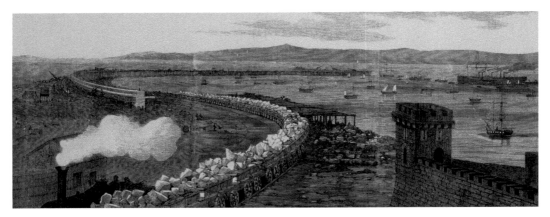

The Holyhead breakwater under construction using a narrow-gauge railway line. Note the ship SS *Great Eastern* in the distance. (*Illustrated London News*, 22 October 1859)

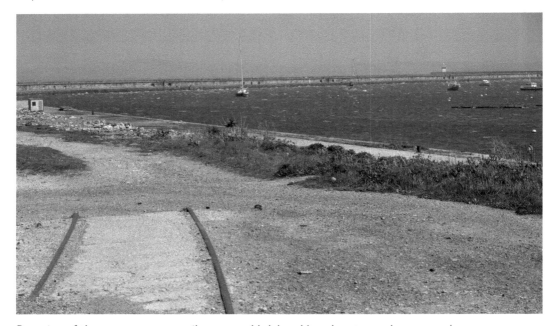

Remains of the narrow-gauge railway near Holyhead breakwater and promenade.

MONA 'MARBLE'

Mona 'marble', although not really a marble, was an ornamental varicoloured green and red rock quarried from Precambrian metamorphic serpentinite at a number of smaller quarries in the west and north-west of the island, of which that at Llanfechell was a favoured source. The furthest known destination of Mona marble is St Helena where furniture, commissioned by sculptor and cabinetmaker George Bullock in 1815, was sent to the exiled Napoleon. The last recorded activities in the quarries were in 1897 for the Stanley monument in Holyhead church, and in the 1980s for the Great Hall fireplace at the National Trust's Speke Hall.

COPPER

On Carmel Head is preserved a chimney of a copper mine, dated 1756 but disbanded in 1868, located on a copper-mineralised fault zone. Such scattered copper deposits are trivial compared to the substantial resource of Parys Mountain. The metal sulphides are enclosed within quartz veins and include chalcopyrite (copper and iron), galena (lead), sphalerite (zinc) and pyrite (iron) with minor quantities of gold, silver, native copper, sulphur, gypsum and dolomite. Early Bronze Age bell pits, up to 50 feet deep, contain wood fragments dated at around 3,500 years ago. Hundreds of elongate beach pebbles around the old workings at Parys are 'hammer stones' used to extract the ore.

Bronze was produced using Cornish tin and is evidence for metallurgists, miners, engineers and toolmakers on Anglesey. 'Bun ingots' of copper with Roman inscriptions indicate workings from AD 61 to AD 410. The fort at Segontium (Caernarfon) managed the considerable wealth of copper mined from Parys Mountain. After a long period of inactivity, on 2 March 1768 local miner Richard Puw found a rich source of copper ore and initiated the 'Welsh Copper Rush'. Copper from the waste rock was hammered by 'copper ladis' wearing gauntlets of iron bands and paid twelve pence for the twelve-hour day. Oak pumps were used because of the high acidity (pH 2) of the water. Colourful iron oxides were sold as pigment. Local lawyer Thomas Williams, father of the Industrial Revolution in Britain, led Parys to be the world's most productive copper mine by 1795 with a workforce of several thousand men. He secured a contract to sheath the wooden hulls of Royal Navy ships, including HMS *Victory*, with copper to protect from shipworm. The ore was originally shipped from Amlwch to smelters in South Wales and Liverpool but later smelted in thirty-one furnaces at Amlwch. Approximately 3.5 million tons of ore were removed between 1768 and 1904, to produce around 130,000 tons of copper metal until cheaper imported copper caused the decline of Parys. The prospect continues to attract commercial interest

This chimney forms the only evidence of a small copper mine on the north-west corner of Anglesey, near Carmel Head.

Above left: Bronze Age hammer stone. (Courtesy of Mr D. Wagstaff).

Above right: Roman copper 'bun ingot' displayed in the Copper Kingdom museum, Amlwch harbour. A similar ingot, displayed in Oriel Môn, found in the Menai Strait is possible evidence of a Roman shipwreck. (Courtesy of Mr D. Wagstaff)

Left: The ore was smashed into smaller pieces with a 4-lb (1.8-kg) hammer by women at the surface, called 'copper ladis'.

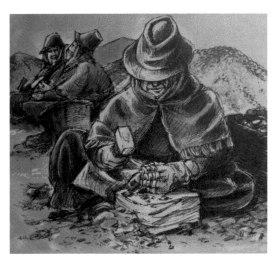

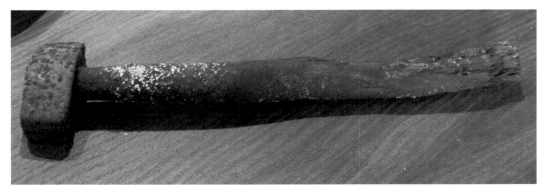

Ore-smashing hammer found in a Parys Mountain shaft. (Courtesy of Mr D. Wagstaff)

Above: Blacksmith's bellows used at the Parys Mountain mine. The miners had to pay for their own tools and their maintenance, and so the blacksmith was an important trade on the mountain. (Courtesy of Mr D. Wagstaff)

Right: Clog used by the miners at Parys Mountain, most likely of Llannerch-y-medd manufacture. (Courtesy of Mr D. Wagstaff)

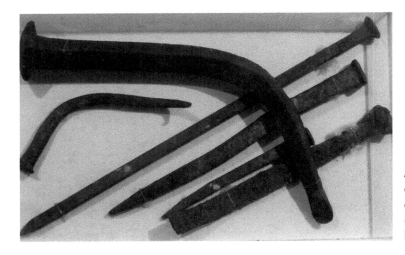

A selection of hardened copper nails. (Courtesy of Mr D. Wagstaff)

Copper sheathing made from Anglesey copper and this fragment, measuring approximately 16 inches by 25 inches, used to sheath HMS *Victory*. (Courtesy of Mr D. Wagstaff)

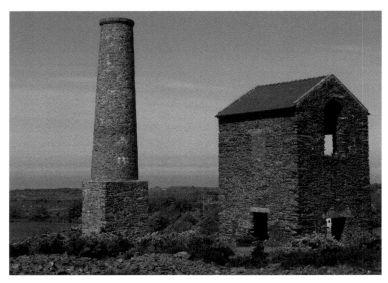

The Pearl engine house and chimney that once housed a Cornish beam engine, one of the earliest steam engines in Wales, conserved by the Welsh Mines Preservation Trust financed by CADW.

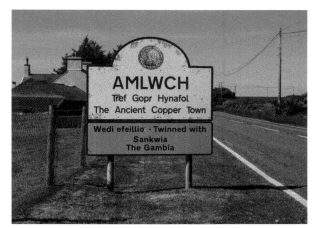

Entrance sign to the 'copper town' of Amlwch.

COAL

The Anglesey coalfield is a minor British coalfield within Carboniferous coal measures downfaulted in the Malltraeth Depression and extends from the Pentre Berw area along Cors Ddyga to under the sea at Malltraeth. Bell pits were sunk during the Tudor dynasty but mining increased from 1700 to 1803 when mines were typically 109 yards deep and used horse winding machines to raise the coal. In 1815 the first steam engine was used to draw the basket and pump out the water by the Anglesey Coal Company Ltd working the Berw coal. By 1840 the pits were 200 yards deep. Five small colliery companies with up to twenty pits have worked the area, of which the Pentre Berw Colliery was opened in 1815 but was closed due to flooding in 1870. The last colliery to close was the Pont Marquis colliery in the early 1880s. Some of the coal was transported to Malltraeth for onward transport by sea before the railway line through Gaerwen opened in 1848. In 1851 there were 140 miners at work but this had decreased to

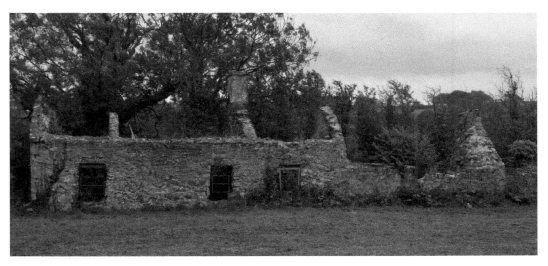

Remains of houses at the Berw Colliery. (Pwll Glo Berw)

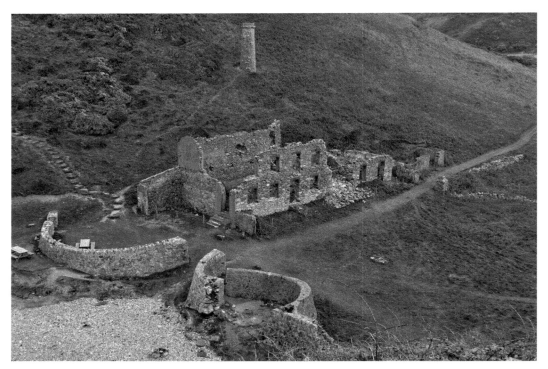

Remains of the Llanlleiana kaolin factory and harbour on this most northerly bay in Wales. Note the remote and elevated location of the chimney, designed to increase the airflow through the factory boilers and furnaces and also to keep the smoke away from the workers. The unusual configuration of the sea-defence walls provided essential protection at this very exposed location.

seventeen by 1877. The site now forms part of the Malltraeth nature reserve managed by the RSPB.

MINOR MINERALS

Chrysotile asbestos has been mined at Carmel Head, and asbestos, steatite (French chalk) and sulphur mined near Llanrhyddlad. Semi-precious jasper was extracted from between the pillow lavas near Llanddwyn Island. At Llanlleiana are remains of the china clay works using local kaolin (quarried from the cliffs to the left of the photograph) and quartzite. The lack of boulders on the beach enabled flat-bottomed boats to land for loading. A fire caused closure of the factory in 1920. Yellow ochre is also present and was exported from near the White Lady cliff for smelting.

BRICKMAKING

A source of employment for Anglesey men at that time, the Holyhead silica bricks company provided further work when the quartzite was quarried to form silica bricks for use in iron furnaces.

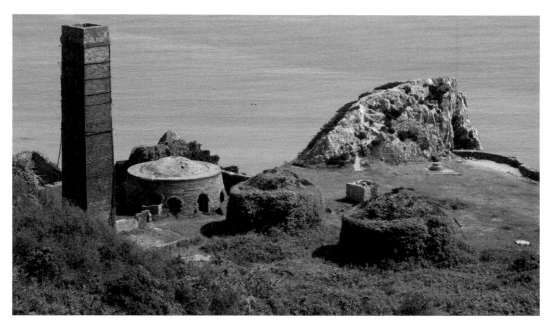

The Porth Wen brickworks, where many of the original buildings and equipment remain.

The Porth Wen Brick Factory had the successful combination of a mineral resource, local labour supply and a navigable harbour. It exploited a deposit of friable quartz- and feldspar-rich sands and clays surrounding white resistant Gwna quartzite. Although the remains of this now disused factory are of early twentieth-century vintage, brickmaking commenced here in 1850 and provided work for men who had been laid off when the Parys copper mine had stopped working. The bricks were perfect to withstand the high temperatures of iron and steel refractories. Brick production reached a maximum in 1906, before it was sold to Charles Tidy in 1908 who introduced a press method of brick production with double

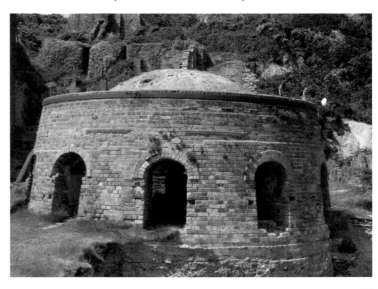

Hoffman kiln at Porth Wen.

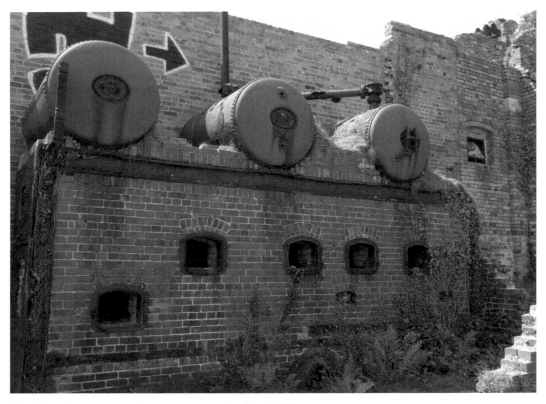

Coal-burning ovens and gas storage tanks, Porth Wen.

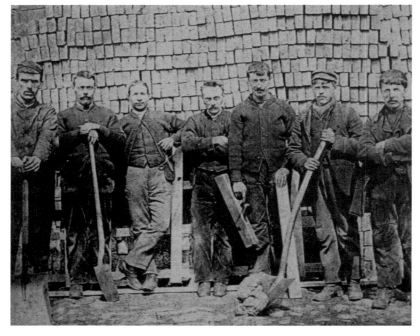

Workmen at the Porth Wen brickworks.

recesses, seen in today's bricks. The kilns were kept hot day and night on a three-shift system by workmen who endured intense heat and poor working conditions. The factory was closed in 1914 but was reopened briefly in 1934 as the Anglesey Brick and Granite Company.

The Cemaes, or Afon Wygyr, Brickworks Company was opened in 1907 in response to a demand for bricks following the growth of the tourist industry but closed at the outbreak of the Second World War. The 92-foot-high chimney still stands and was fed by two parallel versions of the Hoffman type kiln, with the potential of producing 50,000 bricks per week. Wagons transporting coal from the harbour to the kilns and bricks to the harbour were hauled by men and horses along the 2-foot-gauge, 500-metre-long tramway.

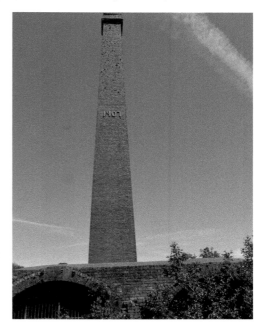

Right: Chimney and brick kiln of the Cemaes brickworks.

Below: Embossed Cemaes brickworks brick. (Cemaes Heritage Centre)

COMMUNICATIONS

Anglesey's workforce travels further than any other North Wales region, with an average of 22.5 km. Holyhead is the third most important port in Wales by freight volume and sea passenger traffic with the Irish Republic.

SEA

Anglesey has a long history of coastal transport, with the historically busiest routes being six small ferries that crossed the Menai Strait. The eleventh-century Abermenai ferry is the oldest documented ferry, followed by the Porthaethwy ferry in 1193 and the Llanfaes ferry operated from Beaumaris to the Lavan Sands from 1292. The Porthesgob ferry between Cadnant and Bangor operated from 1292. The Llanidan ferry crossed from Llanidan to

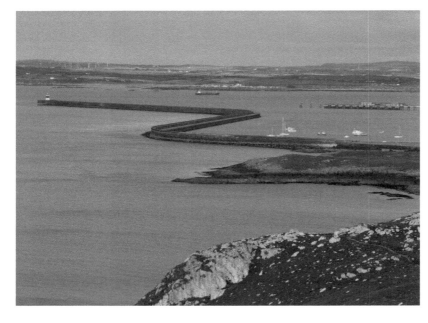

The Holyhead breakwater is the longest in Europe.

Llanfair is Gaer and later from Moel y Don to Felinheli. The Talyfoel ferry worked from Caernarfon to the Anglesey shore in 1425, when landing facilities were so poor that passengers had to be carried to the boat on the back of the ferryman. It was used weekly by men from Brynsiencyn who worked in the Llanberis slate quarries. The building of the Menai Suspension Bridge in 1826 led to the Porthaethwy and Beaumaris ferries becoming redundant but those at Talyfoel, Moel y Don and Garth continued to operate into the second half of the twentieth century.

Although communication between Anglesey and Ireland had existed since prehistoric times, the Act of Union between Britain and Ireland in 1800 increased communication with Ireland through Holyhead port. The Holyhead Breakwater is the longest breakwater in Europe at 1.7 miles (2.7 km), built between 1847 and 1873. In response to the extensive damage to boats during Storm Emma in March 2018, a new breakwater is planned for the inner harbour. The Port of Holyhead covers an area of 240 hectares and handles more than 2 million passengers every year.

Cemaes breakwater, harbour and brick-loading site on the right.

Irish Ferries and Stena Line ferry ships at the Holyhead terminal.

LAND

Anglesey has a dense network of roads that were used lightly for local traffic. The post crossed the Lavan Sands to Beaumaris, shown on the map of 1675, but was moved to a Porthaethwy through Penmynydd route. Parishes were responsible for road maintenance but the main road was united and maintained as the Turnpike Trust in 1765 when road users paid at each tollhouse.

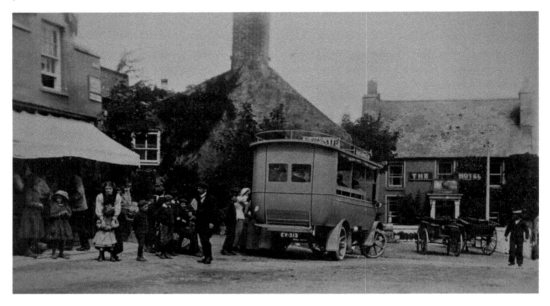

Above: The only privately operated bus service on Anglesey before the First World War served Cemaes to Amlwch using the *Alma* (EY-313), here outside the Stag Hotel in Cemaes in 1913.

Left: The A5 is recognised as a historic route.

The new A5 turnpike road was built by Thomas Telford between 1815 and 1826 to increase the comfort of politicians during their forty-one-hour journey from London to Dublin. Bridging the Menai Strait was a necessity, and Telford began construction of the biggest suspension bridge in the world at that time in 1819. It was completed by 30 January 1826 at a cost of £165,000. Its 100-foot height was dictated by the tallest sailing ship masts that would have to pass beneath it. The arches were constructed of limestone from the Penmon quarry and the bridge suspended from sixteen huge wrought-iron chains that were replaced by steel cables in 1939.

Another major obstacle in completing Telford's A5 turnpike road to Holyhead was the wide valley of the River Cefni. The River Cefni was once tidal for 12 miles upstream as far as Llangefni and presented a barrier to communication. Malltraeth village was previously known as Rhyd y Maen Du (Ford of the Black Stone). The building of the embankment, or cob, at Malltraeth was approved by Parliament in 1790 and completed by 1826. It prevented flooding of rich agricultural land, facilitated coal working at Pentre Berw and provided a bridge at Malltraeth. The new road shortened the journey to twenty-six hours and thirty-five minutes. It was the first Parliamentary road, for which tolls were payable using tollhouses. The A5 was turnpiked with toll stations at Llanfair PG, Nant Gate, Gwalchmai, Caergeiliog and Stanley Embankment until the coming of the railways when competition from rail travel caused the roads to be toll-free. The Anglesey stretch of the

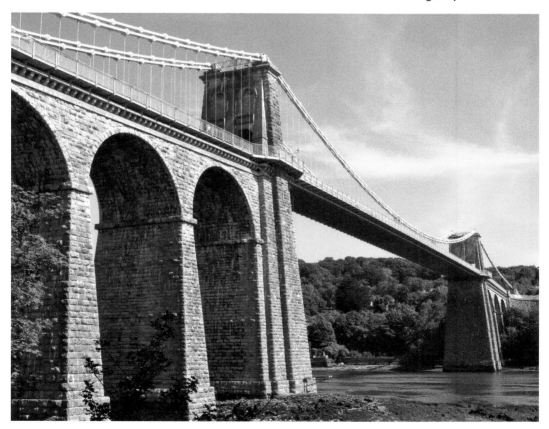

West side of Telford's impressive suspension bridge over the Menai Strait.

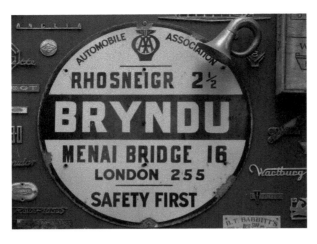

Vintage Automobile
Association sign for Bryndu.
(Tacla Taid Museum)

A5 was the last turnpike to be freed in the country. The bridge is mentioned in Lewis Carroll's *Alice's Adventures in Wonderland*:

> White Knight to Alice:
> 'I heard him then, for I had just
> completed my design.
> To keep the Menai bridge from rust
> By boiling it in wine.'

The Stanley Embankment carried the A5 road to Holy Island where the Admiralty Arch was built between 1822 and 1824 to mark the end of the new A5 road and designed to mirror London's Marble Arch. It is 1.2 km long, was built in one year and opened in 1823. It was widened in the 1840s to accommodate the Chester & Holyhead Railway. In 2001 the A55 trunk road was completed to provide the final link between Ireland and Britain, and with Europe, and designated Euroroute 22. This new road was built with, wherever possible, a sympathetic consideration of environmental aspects including new habitats for water voles, badgers, otters and great crested newts, as well as a new island for the local tern colony.

RAIL

The second and equally important spanning of the Menai Strait is the Britannia Bridge, built between 1846 and 5 March 1850 by Robert Stephenson, bringing rail communication to the island. The Chester to Bangor railway was completed in 1848 and later that year the first railway line on Anglesey operated from Llanfair PG to Holyhead. The new rail link reduced the forty-hour mail coach journey to ninety-one-and-a-half hours. The Cefni Viaduct provided a rail route across the wide Cefni valley. Only two railway tunnels were required. The bridge was located at a narrowing of the Strait over Britannia Rock that supported the central pillar. This was the first ever tubular bridge to be built, with cross-sections rivetted together to make the world's longest continuous wrought-iron span of 1,511 feet in length, each of which weighing 1,500 tons. Of the 2 million rivets used in its construction, the last two were placed by Stephenson. The two railway lines were housed in separate tubes, but united by a common tar-covered roof. The bridge remained as a sturdy railway link to the

island until the evening of 23 May 1970, when it was damaged by fire. It was completely replaced by an open lattice steel-arched bridge with two railway lines. In 1980 a road deck of the A55 was added above the railway. Robert Stephenson's achievement in constructing the Britannia Bridge is commemorated in a memorial window in Westminster Abbey's north choir aisle.

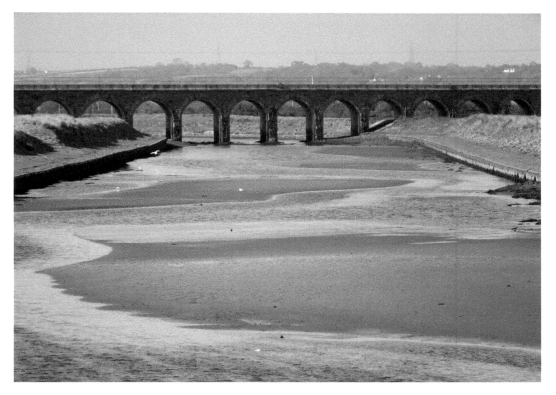

Above: The Cefni railway viaduct, looking up the channelised River Cefni from Malltraeth.

Right: The Britannia railway bridge is now a road and rail bridge.

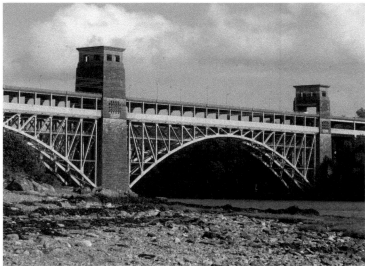

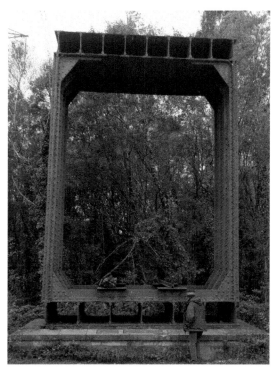

Left: Part of the original box girder bridge of the Britannia.

Below: The Kingsland Bridge keystone was on the Bont Pellech Nest bridge originally constructed by the Chester & Holyhead Railway. The line was officially opened on 1 August 1848.

Right: LMS vintage poster displayed in the Holyhead breakwater open-air exhibit.

Below: The 1228 Holyhead to Bangor train crossing the nineteen arches of the Bodorgan Viaduct.

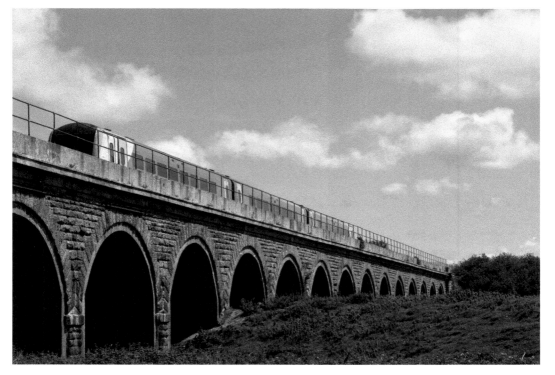

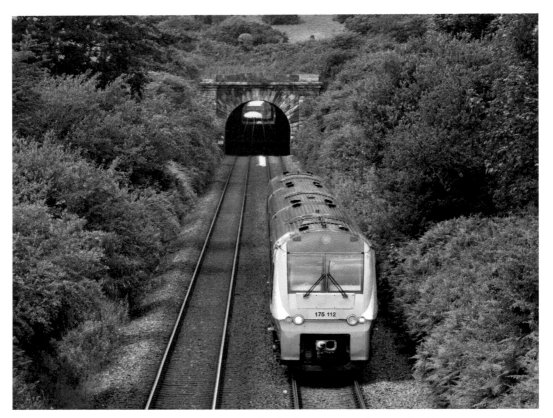

The 1228 Holyhead to Bangor train exiting the Bodorgan tunnel, one of only two tunnels on the island.

AIR

Anglesey has two military airports and one civilian airport, Mona is the oldest, commencing in September 1915 during the First World War as an airship station to mount anti-submarine patrols over the Irish Sea. The airship base closed during 1920 until it became Valley's Relief Landing Ground from 26 July 1951 and later as an Advanced Flying School. In 2006 the National Assembly for Wales subsidised a weekday public air service between the Llanfair-yn-Neubwll airport and Cardiff Airport. The twice-daily service commenced in May 2007 with the airport's principal stakeholders being RAF Valley, The Senedd, the Isle of Anglesey County Council and Cardiff Airport.

UNDERSEA CABLE

In 1871 a communication cable was laid by the GPO between Porth Crugmor to Howth (Ireland) and was 64.5 nautical miles in length. Another cable extends from Cable Bay on Anglesey and is connected to Ireland by a marine fibre-optic cable. The CeltixConnect consists of seventy-two fibre pairs and was laid in January 2012 from Porth Dafarch to Dublin.

PRINTING AND PUBLISHING

Publishing on Anglesey started in 1735 when Lewis Morris established a printing press at Holyhead to publish Welsh literature. In Bodedern in 1759, teacher John Rowland printed books of Welsh ballads and theological works. During the Methodist revival, between 1820 and 1850, printing presses published two monthly magazines at Holyhead and Llannerch-y-medd. The first Anglesey newspaper, *Llais Y Wlad* (*Voice of the Country*), and a Welsh satirical equivalent to *Punch* was printed at Holyhead by Lewis Jones between 1857 and 1861. The *Holyhead Mail* and *Anglesey Herald* were published at Holyhead in 1881, followed by the Welsh weekly paper *Y Clorianydd* at Llangefni. Today Llyfrau Magma, at Llansadwrn, publishes numerous highly informative books on Anglesey.

MAJOR INDUSTRIES

AIRSHIPS

Mona Airfield was the Royal Naval Air Service base for airships adapted for sea patrol and for attacking German submarines that were threatening coastal shipping and the Holyhead to Dublin ferry. It was commissioned on 26 September 1915 when the first airship, Sea Scout (SS) *18*, arrived. Controlling the airships was not an easy task and SS *18* was seriously damaged on 9 October 1916 when it struck a cow on landing next to the airfield and drifted uncontrollably out to sea until it landed in Ireland on the 22nd. The airships performed a vital function but were replaced by more durable and quicker twin-engined seaplanes.

AIRCRAFT ENGINEERING

The first plane to fly into Wales was in 1910 by Robert Loraine. Research and development on aeroplane aerodynamics was led by Ellis Williams at Bangor University but the planes were tested at Llanddona, where the test plane was called *Bamboo Bird*. With a more powerful engine, the plane made its first successful flight to Red Wharf Bay in 1911.

The Fryars estate near Llanfaes was requisitioned during the Second World War for the Saunders-Roe aeroplane manufacturing company to modify American- and Canadian-built Catalina flying boats. From 1939 to 1943, 399 Catalinas were adapted for RAF needs, including specially designed Browning machine guns, British bomb racks and RAF radio equipment. Air to Surface Vessel radar (ASV) and powerful Leigh lights enabled the spotting of German U-boats at night in the Irish Sea. After the war, the engineers used aluminium to manufacture torpedo boats, patrol boats, hydrofoils, airborne lifeboats and floats for Auster light aircraft. It later produced a wide variety of civilian and military land-based craft including buses, of which 620 were exported to Cuba in the 1950s, when it employed 2,000 people. The factory was closed in 1997.

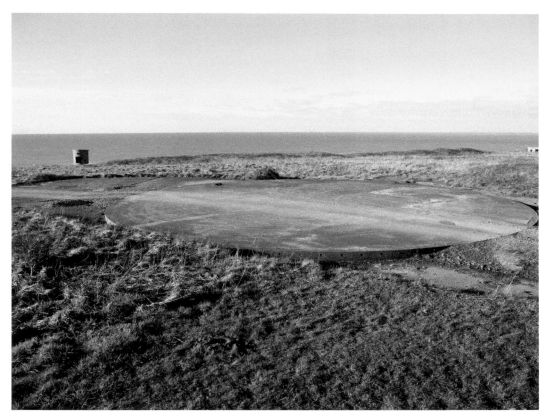

The TEGWRA circular rocket-launching pad with support railway line near Aberffraw.

TEGWRA

Ty Croes camp at Aberffraw was opened in 1941 for anti-aircraft training, developing later into a surface-to-air guided missile testing base. It became a testing site, as TEGWRA (Trials Establishment Guided Weapons Royal Artillery), for Thunderbird guided missiles in 1959 using Royal Artillery and RAF personnel. Many Second World War sites remain around the island, indicating its readiness to defend Anglesey and Britain from attack from the sea. The site was abandoned in 1980 and transformed into a racing circuit in 1993.

ELECTRICITY

Electricity provision has generated considerable work since the early twentieth century. The first electricity service was provided at Holyhead in 1906 by a steam-powered generating station. This was followed by a waterwheel generator at Menai Bridge that served Llangefni. In 1931, the island was connected to the mainland grid fed from the hydroelectric power

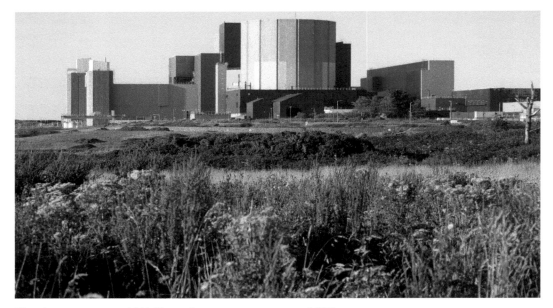

The decommissioned Wylfa nuclear power station in 2020.

station in the Conwy Valley at Dolgarrog. That power source sadly terminated when the two dams on the Eigiau above Dolgarrog failed on 2 November 1925, killing sixteen people. After the Second World War, every house on Anglesey was provided with electricity. In the late 1960s a new power line was established across Anglesey to operate at 400,000 volts. The remote location of Anglesey, with access to seawater for cooling the reactors, made it a prime location for siting the Wylfa Magnox nuclear power station west of Cemaes Bay, the second to be built in Wales. Work started in 1963 and generation commenced in 1971. After five years of decommissioning, the final flask of a total of nearly 90,000 fuel rods left this last Magnox power station in September 2019.

WIND FARMS

Since 1997, power generation on Anglesey has been increasingly supported by wind farms. The first is located at Llanbabo and Llyn Alaw and has thirty-four turbines. The second wind farm is at Trysglwyn Farm, near Parys Mountain, and has nineteen turbines, and a third at Rhyd-y-Groes near Cemaes has twenty-four turbines. Located off the north coast are more than twenty wind turbines. There is no doubt that wind turbines provide clean energy, but their benefits must be considered alongside their negatives, such as their environmental impact on bats and birds, landscape and visual impact, loss of natural land, electromagnetic production, and cost – during manufacture, set-up, maintenance and decommissioning.

OIL IMPORT

The rise of supertankers in the 1960s made it increasingly difficult for imported oil to be transported through the busy Mersey Estuary to the Shell Oil refinery at Stanlow in

Cheshire. The problem was solved by an oil-receiving single-buoy mooring, 21 metres in diameter and weighing 500 tons, in the deep sea offshore at Amlwch. The oil was then pumped ashore to Rhosgoch and then along two 36-inch-diameter pipelines over 127 km to Stanlow. The first supertanker was offloaded in 1974 and the last in the mid-1980s.

OCTEL BROMINE

Poor-quality fuel during the early days of motoring was improved in 1920 by adding tetraethyl lead with dibromoethane, a derivative of bromine. Pure sea water provided a ready source of bromine, and the clear waters off Amlwch were ideal for the process. Associated Ethyl Company Ltd was established in 1953, followed by Associated Octel Company Ltd in 1961. The use of non-leaded fuel in the 1980s reduced the demand for this chemical and the plant closed in March 2004 with the loss of 120 jobs.

ANGLESEY ALUMINIUM

A ready and continuous source of electricity from the Wylfa nuclear power plant led to the establishment of an aluminium smelter on the outskirts of Holyhead. Aluminium production at the Anglesey Aluminium Metal Ltd commenced in 1971. It was one of the largest employers in North Wales with 540 staff and produced up to 142,000 tons of aluminium every year.

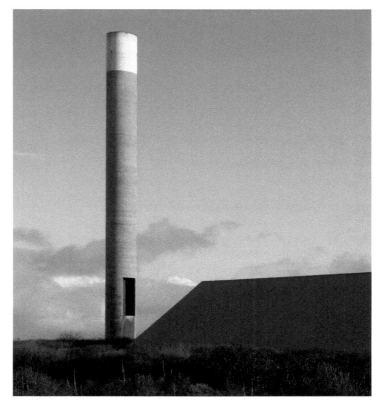

The chimney stack of
Anglesey Aluminium
remains in 2020.

The company's private harbour at Holyhead accepted bauxite and coke from Jamaica and Australia and the aluminium ingots were transported by railway to the Holyhead to London main line. When Wylfa was closed in 2009 there was no alternative but to close the smelter, on 30 September 2009, leading to a workforce reduction from 450 to eighty. This was a major blow to the island's economy and especially to Holyhead. A nearby factory, ALPOCO, has produced aluminium powder and granules since 1970.

RAF VALLEY

RAF Valley is now the 22 Squadron Search and Rescue headquarters. The station opened as RAF Rhosneigr in 1941 but was renamed RAF Valley after two months when it operated as a fighter station during the Second World War. The Mountain Rescue Service was formed in 1948, and it has saved many lives in the region, especially in and around the flanks of Snowdonia. No. 4 Flying Training School commenced at Valley in 1960 and the Search and Rescue Training commenced in 1962. It is home to Squadron 202 RAF, and both RAF and Royal Navy pilots transitioning from Basic Flying to fast jets are also trained here. It serves as a command-and-control centre for three Valley-based RAF teams as well as those at Lossiemouth and Leeming. RAF Mona provides a landing field for the Valley Flying Training School operating the Hawk T2 aircraft. Since 2019, RAF Valley has been the home of Basic Flying Training, the second phase of Fast Jet training for the RAF and Royal Navy. Following on from Elementary Flying Training, Basic Flying Training using the Texan T1 advanced turbo-prop trainer will prepare students for Advanced Flying Training on the Hawk T2 jet trainer.

The RAF Valley Station Badge depicts a dragon rampant holding a portcullis. For many years RAF Valley took pride in being a Master Diversion Airfield and remained open twenty-four hours a day to receive aircraft either in difficulty or diverted from other bases because of bad weather. The station adopted the heraldic devices on the badge as an indication of both its location in Wales and its task of holding the entrance to the airfield open.

WATER SUPPLY

Rivers, springs, wells and rainwater were the water sources of the Anglesey country folk and were sufficient until the population started to increase. There are a few natural lakes, mostly in the west, such as Llyn Llywenan, the largest on the island, Llyn Coron, and Cors Cerrig y Daran, but rivers are few and small. The Holyhead Water Company used Ffynnon y Wrach (Witches Well) at the northern part of Holy Island to supply water to Holyhead in the 1860s. Additional supplies from Lake Traffwll were used as a reservoir and other towns formed their own water supply companies. The rapid increase in population during the Second World War forced the county council to search for a greater water supply, and this council was the first and only county in England and Wales to become its own water authority, on 1 January 1945. Lake Cefni was created in April 1951 by damming the River Cefni but even this supply became insufficient when water expectations of Wylfa's nuclear power station were considered. The Alaw reservoir, Anglesey's largest lake, was constructed over the former peatland of Cors y Bol between 1963 and 1966.

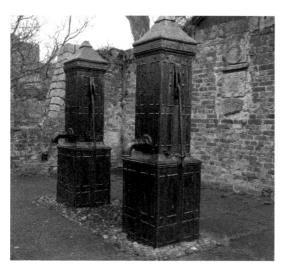

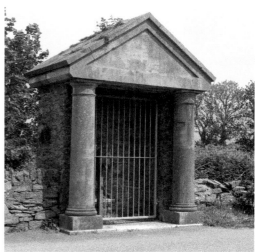

Above left: Victorian water pumps at Beaumaris.

Above right: Bodedern water pump inside a Doric-style building donated by Lord Stanley in 1897 in memory of Captain James King, Sheriff of Anglesey.

Below: The Cefni reservoir was created by damming the River Cefni in 1951.

LAND ROVER

The first Land Rover off-road utility vehicle was the brainchild of Maurice Fernand Cary Wilks (1904–63) who periodically lived near Newborough. He was the Chief Designer of the Rover car company and, after the war, he and his visiting brother contemplated a sturdy replacement for his broken ex-army Willys-Overland jeep. The prototype, HUE 166, was built on the Willys chassis mid-1947 and tested at Red Wharf Bay. Rover produced fifty pre-production models by September. Launched at the Amsterdam Motor Show in 1948, it provided work at the Rover factory during its decline due to a steel shortage after the war. It reached 60 mph with a centrally positioned steering column, and it was hoped that its similarity to tractor steering would appeal to farmers. The cheap aluminium was from scrapped aeroplanes and the green paint was that used for aircraft cockpits. When the new Defender was launched in Frankfurt in September 2019, the achievement was painted on the side as: 'Wilks Bros., 4x4 Specialists Since 1948'. The two-millionth Land Rover S90HUE was a Defender and had a map of Red Wharf Bay embossed on the front wheel arches.

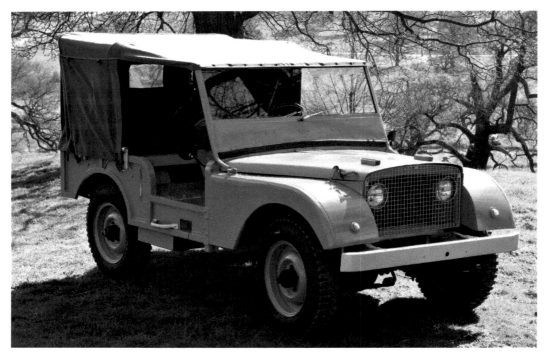

Replica of the first Land Rover. (P. Bashall of the Dunford Collection of Land Rovers)

SMALLER INDUSTRIES

BREWING AND DISTILLING

Mead, cider and beer was produced on the island for both recreation and religious purposes. Indeed Llannerch-y-medd indicates the strong link between this town and mead making. Smuggled rum from the Isle of Man was common in the eighteenth century, when a sweetened mixture of brandy and water known as 'todi' was popular. The high influx of miners to work in the Parys copper mines created a demand for beer that led to the establishment of Amlwch Brewery, or Brewas Borth, in 1780. This was the largest brewery, supplying twenty-one taverns in 1828. In 1845, it sold brandy for 25 shillings a gallon, ale at 45 shillings a barrel and Amlwch porter at 45 shillings a barrel. One of its drays was the first

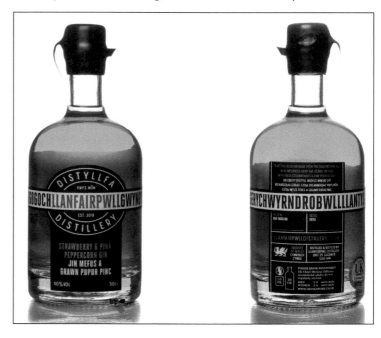

Môn Distillery strawberry and peppercorn gin from the longest-named village.

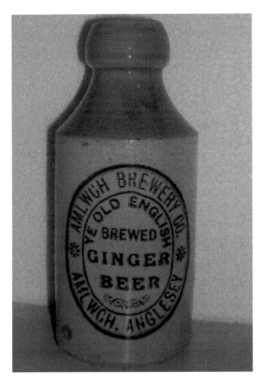

Amlwch Brewery ginger beer bottle.

commercial vehicle to cross the newly opened Menai Suspension Bridge. The 1830 Beer Act led to closure of many breweries, and only seventy licensed beerhouses were in Amlwch by the end of nineteenth century.

The Mona Brewery, near Llanfachreth, was established by 1836 and employed ten men in 1845. The beer was dark and strong and sold for £1 3s a half barrel. Brewing ceased in 1895 due to arson and the rise of temperance.

Water from a spring on Dafydd Thomas's Porth Yr Odyn Farm near Pentraeth was the source of the Anglesey Spring Water company that developed into the Môn Distillery that created Anglesey's first whisky for more than 118 years. The company diversified during the Covid-19 pandemic to produce hand-sanitising fluid. Gin manufacture has recently commenced at Melin Llynnon using botanicals that grow around the mill. Bragdy Môn, the Anglesey Brewhouse, began test brewing in September 2017 at Rhostrehwfa. Gin produced at the Llanfairpwll Distillery has the world's longest name printed around the bottle. Vegan-friendly, gluten-free Welsh cider (Seidr Ynys Môn) using Anglesey apples and pears has been brewed by Jaspells since 2015 at Bwlan Barn, Aberffraw.

MARRAM

Marram grass (*Ammophilia arenaria*) or *moresg* in Welsh, is up to 1 m tall and grows extensively on the Newborough sand dunes where it was planted to stabilise the dune sand. The earliest mention of marram is in the sixteenth century when Queen Elizabeth banned marram cutting, except around the town, to halt the migration of dune sand.

Platted marram displayed at the Pritchard Jones Institute, Newborough.

Marram mats and ropes were the sole occupation of the Newborough people in 1629. Marram was harvested every two years in the summer and gathered into bundles, or *gafrod*. Worked by the women, marram mats were the main product with haystack coverings 80 m long made from mats sewn end to end. Some mats were bartered in the shops for food or goods. Other marram products included brooms, fishing and rabbit nets, ropes, box bed mattresses, baskets and, later, decorative items. They were also used at the Parys copper mine as kneelers, filters and brooms. The cooperative Newborough Mat Maker Association was formed in 1913 by Colonel Cotton, the driving force behind the first Women's Institute in Britain, of Llanfair PG and established a fixed value for marram products and an end to bartering.

BOOTS, CLOGS AND CANDLES

Each district of Anglesey had its own boot and clog makers until the middle of the nineteenth century, but there was a tendency for boots to be made in Llannerch-y-medd and clogs in Llaneilian and Pensarn. Llannerch-y-medd employed 250 cobblers in 1833 and was the centre of a busy shoemaking industry supporting Parys copper workers, as clogs could withstand the arduous underground conditions. The industry declined after 1870 due to competition from shoe and boot factories in Northampton.

WIND DOLLS

These most unusual objects were designed by Cemaes watercolour artist John Hywel Lewis (1900–50). He was a cobbler in a workshop near the Stag Inn but decided to sell his brightly coloured wind dolls as souvenirs to tourists for 2 guineas each, leading to a worldwide market.

Two hand-made Lewis wind dolls.

ABERFFRAW BISCUITS

The oldest biscuit in Britain is named Aberffraw cake or *teisen Berffro*, and is a shortbread with a distinctive scallop shell shape that originated in the thirteenth century at the request of the wife of a Welsh king at the Aberffraw palace. She asked for a cake to be baked in a shape resembling a scallop shell from the beach. These are also known as James cakes, likely after St James, who had a scallop as his emblem. Pilgrims to Santiago de Compostela, where St James was reportedly buried, often wore a scallop symbol in his honour.

Aberffraw biscuits as baked on Anglesey by the Hooton family and sold in their farm shop at Llanedwen.

Halen Môn seawater holding tank.

ANGLESEY SEA SALT

Salt has been evaporated from sea water on Anglesey since the Roman times and continued on Salt Island until 1775. In 1999 Alison and David Lea-Wilson experimented by evaporating the clear sea water off Brynsiencyn in the Menai Strait and the flavour of the pure white salt crystals convinced them that they had discovered a new venture for them and for the island. This pure source of salt is now pumped ashore, carbon filtered and put into commercial boilers whenever the salinity reaches a certain level. The quality of Halen Môn is so high that it has been awarded Protected Designation of Origin status.

MARKET GARDENING

Supplying local shops, restaurants, hotels and local people with fresh organic vegetables and fruits has great appeal and several market gardens have become established. Produce at Hooton's garden, farm shop and café at Llanedwen is predominantly from their own fields with mostly organic and free range produce, including fruit juices from their own orchards. Smaller establishments are scattered over the island, the most recent being owned by Ruth Jennings at Llanfaes, who offers a variety of seasonal fruits and vegetables.

Organic market gardening run by Ruth Jennings at Llanfaes.

SOAP MAKING

In the ancient town of Beaumaris, the old post office and sorting office have been filled with a variety of fragrances since 2018. Cole and Co. was established in Beaumaris in 2000 and expanded from a small-scale, kitchen-table production of soaps and candles in 2010. The products include original fragrant soaps that are adventurously scented and are marketed throughout Wales and beyond. The handmade soaps include those made from olive oil with Anglesey sea salt.

The soap and candle workshop of Beaumaris.

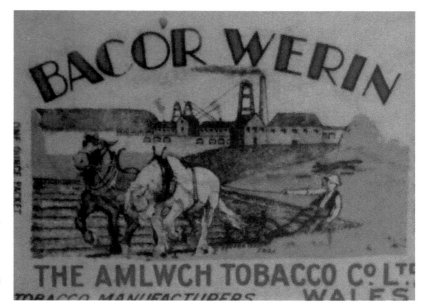

Advertisement for an Amlwch tobacco: *Baco'r Werin*, the 'tobacco of the locals'.

TOBACCO

The Parys copper industry led to a rapid growth in the tobacco and alcohol industry. Amlwch became the centre of tobacco processing and selling, with three tobacco works. One of the first companies was William Mostyn, in 1830, which later became the Amlwch Tobacco company. Morgan & Jones became established in 1844 and manufactured tobacco and snuff until 1985. Cigarettes were only produced by Edward Morgan Hughes, established in 1868. Tobacco powder, known as snuff, was marketed as 'Llannerch y Medd dust'. The three works employed twenty-two workers in 1901.

AGRICULTURE SUPPORT

The AD Llyn Cerrig Bach Iron Age hoard, found in 1942 near Valley, provides the earliest evidence of blacksmith activity on the island in the form of iron bars and tongs. More recently, blacksmiths provided a vital role by providing and fitting cow shoes to cattle to protect their hooves prior and during the long walk to London. There were 216 blacksmiths working on Anglesey in 1911, most of whom were occupied in shoeing workhorses prior to the arrival of tractors. The last blacksmith at Cadnant, Menai Bridge, closed in 1980, but numerous street and house names containing the word *gof* testify to their widespread distribution. In addition to horseshoeing, the blacksmiths made and repaired all kinds of ironwork including tools, implements, gates and wagon parts. Every town and village had a saddler who made saddles, harnesses and collars for workhorses. As with the blacksmiths, this trade declined when tractors became popular. Farmer's gigs and carts were made by several companies on the island, of which the largest was that of Hughes & Co. of Llangefni. Not only were carts essential to farm life, but more elegant gigs were a sign of affluence before the popularity of the motor vehicle. Four blacksmiths are still active on the island, most of which perform farrier services.

PLASTIC MOULDING

In 1974 a German company established a plastic extrusion plant in Amlwch. The company was successful, employed over 150 people and received considerable investment in 2008. Despite 106 people being employed in 2015, a 70 per cent decline in demand led to the company being closed in 2019.

BUDENBERG GAUGE

A factory manufacturing gauges for pressure management and calibration was established in Amlwch in 1962. The Budenberg Gauge Co. Ltd was founded by Mr C. F. Budenberg and Mr B. Schaffer in 1849 when they invented a Diaphragm Pressure Gauge. The company expanded rapidly in Manchester and Altrincham but later moved to Anglesey. Despite employing over sixty people, the factory was closed in 1991.

OFFSHORE TIDAL ENERGY

In 2018, Minesto commissioned its first commercial-scale system in Holyhead Deep, Wales. With the 0.5MW DG500 device, Minesto could generate electricity for the first time with a commercial-scale unit. The Lynas Shuttle boat serviced the project. The vessel provides out of port services for Point Lynas anchorage, Liverpool Bay and for the numerous vessels participating in the construction of the Gwynt Y Môr Wind Farm.

The Lynas Shuttle boat at Amlwch harbour.

MENAI SCIENCE PARK

Menai Science Park Ltd (M-SParc) is the first science park in Wales and consists of an ultra-modern, three-storey building covering an area of 5,000 square miles near Gaerwen. At a cost of £20m funded by European Regional Development Funding through the Welsh government, the science park is a Bangor University company and was opened in 2018. The purpose of the park is to provide support for new and established businesses in an innovative exciting environment, helping support groundbreaking idea generation and diversifying the region's economy by creating new, well-paid careers. The park boasts well-equipped meeting rooms, offices, and wet and dry labs. M-SParc has been established to provide a range of advantages and benefits for knowledge-based research and development, technology and digital businesses. The park is linked to world-class universities, including Bangor, and is particularly interested in companies who are in the low carbon, energy and environment, ICT and natural products sectors.

Work on Anglesey continues to diversify and includes artisan bakeries, woodturning at Llanfachreth, and ice-cream manufacture at Benllech and Trearddur Bay. Vineyards are established at Llanbadrig and Red Wharf Bay, of which the former is the most northerly vineyard in Wales. The dramatic scenery of Anglesey has led to it being used as a set for several films, the most recent of which was a BBC film on Llanddwyn Island featuring four families who give up the trappings of modern life and survive on the island under conditions typical of 1900.

The Menai Science Park is the first science park in Wales.

THE NATURAL ENVIRONMENT AND ITS PROTECTION

Numerous activities are at work to preserve the present faunal and floral diversity on Anglesey from intensive agriculture and human impact. Anglesey occupies a particularly important position in terms of its insular setting, maritime climate, geodiversity and relief. The resulting biodiversity is especially precious, and its preservation is a continuous battle against wanton destruction by human activities. The environmental impact of past human activities would have been minimal compared to the impact of post-Victorian population explosion.

The first coastal nature reserve in Wales was bestowed on Newborough Warren and Ynys Llanddwyn in 1955. The Warren is one of the largest and finest dune systems in Britain and is a home to a high diversity of plants and animals including red squirrels. Its highly varied history spans from the submarine eruption of Precambrian lavas to marram collecting and weaving by the women of Newborough.

HERITAGE COAST

Three stretches of coastline have received this designation with the intention of preserving them from insensitive developments. The North Anglesey Heritage Coast extends from Church Bay to Dulas Bay, the Holyhead Mountain Heritage Coast extends from Trearddur Bay to Holyhead, and the Aberffraw Heritage Coast between Malltraeth and Aberffraw bays.

SPECIAL PROTECTION AREAS

Special protection areas have been identified by Natural Resources Wales (NRW) in conjunction with the UK Joint Nature Conservation Committee to protect bird species which are highly rare or vulnerable or which regularly migrate to the shores and currently include the Anglesey Terns, Lavan Sands and Puffin Island.

AREAS OF OUTSTANDING NATURAL BEAUTY

Holyhead and Bodafon mountains and almost the entire Anglesey coastline have been designated an Area of Outstanding Natural Beauty 'to conserve and enhance the natural beauty of the landscape'. Sadly, this definition permits recreation, agriculture, forestry and other 'uses'. In these times of great pressure on the natural environment and insufficient monitoring of its destruction it is time for the definition of AONB's purpose to be more inclusive and protectionist of the coastal zone.

SITES OF SPECIAL SCIENTIFIC INTEREST

Areas designated such by NRW are of land and water that are considered to best represent the natural heritage in terms of flora, fauna, geology and landforms. Wales has around 1,000 SSIs covering 12 per cent of the land area. Anglesey has sixty-two SSIs. There are many sites of importance for nature conservation despite the invasive presence of humans on the island over the centuries. It is conceivable that the island would have escaped extensive ruination of the natural environment if the demand for agricultural and recreational use was not so high. Anglesey has one of the highest densities of Sites of Scientific Interest in Britain.

NATURE RESERVES AND RSPB

Nature reserves are areas set aside for the purpose of protecting the biodiversity of an area by preserving and encouraging all wildlife but especially endangered forms. The island has eighteen nature reserves. The RSPB is responsible for the Valley Wetlands, Cors Ddyga, South Stack and The Range and eight are under the control of the North Wales Wildlife Trust. Four sites are considered National Nature Reserves on Anglesey and include the unique fenlands (*cors*) of Cors Erddreiniog, Cors Goch, Cors Bodeilio and the area of

Bitterns have returned to the RSPB Cors Ddyga wetland nature reserve, an event commemorated in this lifelike wood sculpture.

The rare marsh fritillary butterfly at Cors Erddreiniog. (Courtesy of Susan Loose)

Newborough Warren and Llanddwyn Island. These unique areas create refuges of natural vegetation that will help wildlife to flourish, including the rare marsh fritillary butterfly, in a region that is otherwise mostly characterised by a desert of grassland.

RED SQUIRREL RECOLONISATION

The native red squirrel has suffered, almost to extinction, from competition from its imported rival the grey squirrel. The Red Squirrels Trust Wales (RSTW) is dedicated towards to successful recolonisation of Wales by red squirrels and the eradication of the grey squirrels. The Trust has significantly increased the survival of the red squirrel on the island. Not only was there competition from the grey squirrels, who also carried a deadly virus fatal to red squirrels, but their natural broadleaf woodland habitat had been severely reduced. In the late 1990s the red squirrel population of Anglesey had fallen to around forty individuals in one woodland. In 2011 there were fewer than 1,000 red squirrels in Wales, of which around 300 lived on Anglesey having the advantage of physical detachment from the mainland and a 1-km-deep 'grey squirrel free zone' created by the Trust on the mainland. The success of the project was greatly due to landowner support and assistance from volunteers who checked traps and feeders, recorded nest box sightings, led walks and provided workshops. The project is an excellent example of altruistic work on the island. Due to the work carried out by the RSTW, Anglesey was designated grey squirrel free in 2013.

Above: One of Anglesey's red squirrels. (Courtesy of Sonjia Bradley)

Right: Anglesey black-tailed red squirrel at feeder in a reserve.

The Wales Coast Path is well signposted.

COASTAL PATH

The Anglesey Coastal Path is a 200-kilometre (124-mile) long footpath around the island and is part of the Wales Coast Path. 95 per cent of the coastline is designated an Area of Outstanding Natural Beauty and includes a mixture of farmland, coastal heath, dunes, salt marsh, foreshore, cliffs and a few small pockets of woodland. The path is maintained by a series of local authority path officers who ensure rights of way and path safety.

FENLAND PRESERVATION

Restoration and repair of the Anglesey Fens, under the Living Landscape project, is being jointly managed by Natural Resources Wales, North Wales Wildlife Trust, Dŵr Cymru and Anglesey Local Grazing Partnership. Their work aims to reduce water removal and agricultural runoff, remove invasive non-native plants and to connect the key sites to facilitate wildlife flourishment. Fenlands are a type of wetland fed by underground aquifers, and the limestone geology of eastern Anglesey supports the second largest expanse of fens in the UK. These unique areas provide refuges of natural vegetation that promote the flourishing of wildlife in a region that is otherwise mostly a nature desert of grassland.

Unlike the acidic waters of the East Anglia fens, those of Anglesey are alkaline, of which the largest three are also National Nature Reserves and include Cors Erddreiniog, Cors Bodeilio and Cors Goch. They are vegetated by reeds, sedges and rushes and support a variety of wildlife.

GEOPARK

Anglesey is recognised as a UNESCO Global Geopark. The geopark is involved with all stages of education including geo-guided courses and field excursions for the public and colleges/universities, and its director, Dr Margaret Wood, shows tireless enthusiasm for the project. Fifteen geo-information boards are located at 'hot spots' around the island and publications include books on Anglesey's geology and soils. They provide volunteer training for local communities on the island and engage with all local events. The coastal path provides access to 90 per cent of Anglesey's geological highlights.

One of Geomôn's popular information boards at selected sites of special geological interest. This one describes the geology of Holyhead Mountain.

ARTISTS

L
ying off the coast of the Snowdonia mainland, Anglesey enjoys more sunny days than most parts of Wales. This, and the high variety of resident and migratory birds, has encouraged local artists and several non-local artists, some of whom have focussed on landscapes and seascapes while others have chosen the animals, birds and plants as their speciality. A few, such as Charles Tunnicliffe and his contemporary Sir Kyffin Williams, have achieved global fame while extant artists continue to produce magnificent depictions of the ever-changing landscape of Anglesey and Snowdonia, such as Wyn Hughes, and of wildlife, such as Philip Snow.

The abundance of fine art is displayed in numerous galleries (*oriel*) on the island including those of Oriel Ynys Môn at Llangefni, Oriel Cemaes, Oriel Ger-Y-Fenai in Llanfair PG, Oriel Beaumaris, Janet Bell and Stephen Jones galleries in Beaumaris and Oriel Daniel in Llangefni.

Charles Tunnicliffe OBE RA (1901–79) settled at Shorelands on the Cefni Estuary at Malltraeth in 1947. He was one of the world's greatest wildlife artists and was able to record the daily wildlife activities of the nearby estuary in sketches and watercolour. His 'feather maps' documented the size and distribution of feathers, which enabled him to paint with remarkable realism and accuracy. The significant contribution to the art world of these 'maps' was realised by Kyffin Williams who persuaded Tunnicliffe to exhibit them at the Summer Exhibition of the Royal Academy in 1974. His published bird sketches capture the spontaneity of wildlife. He illustrated numerous books, including the Ladybird children's nature series and Brook Bond Tea cards. His sketchbooks and feather maps, drawings and magnificent paintings are housed in the purpose-built Oriel Môn at Llangefni. The entire collection was saved from dispersal by auction in 1981 when they were purchased by Anglesey Council. One quote that sums up his dedication is when asked why he didn't visit London more often, he replied 'I prefer the birds of Anglesey to the birds of Piccadilly.' He despaired of the destruction of wildlife in response to modern man's imposition, pollution and shooting – negative influences that sadly continue to deplete the wonderful balanced gift of nature. He said, 'Will many of our birds be but a memory in a few years to come.' It is hoped that his illustrations do not become the remnant representations of precious Anglesey wildlife.

Sir Kyffin Williams OBE KBE RA (1918–2006) is best known for his depictions of the Welsh countryside, shepherds and their sheepdogs, livestock and small villages. He is considered the defining artist of twentieth-century Wales. Most of his paintings were made with impasto

C.F. Tunnicliffe R.A.
Sketches of Bird Life

Edited with an introduction by Robert Gillmor

Sketches of Bird Life by C. F. Tunnicliffe illustrates his attention to detail and depiction of lifestyle and habitat.

palette knife marks with few brushstrokes and minimal colours, based mostly on the greys and greens of the Welsh rocks and vegetation. He was born in Llangefni, died in Llanfair PG and is buried in Llanfair-yn-Nghornwy. He studied at the Slade School of Fine Art in London and received a Winston Churchill Fellowship to paint in Y Wladfa in Patagonia. His works are in the collections of the National Library of Wales, the Government Art Collection in the United Kingdom, and the National Museum of Wales. His works have gained worldwide attraction and many are on permanent display in the Oriel Kyffin Williams Gallery that opened in 2008 at Oriel Môn in Llangefni, where he is also honoured in a life-size bronze sculpture. His former home 'Min Y Môr' lies on the banks of the Menai at Pwllfanogl. His love of Wales is expressed in this quotation: 'My Welsh inheritance must always remain a strong force in my work, for it is in Wales that I can paint with the greatest freedom.'

Gwendolen Massey (1864–1960) provided 506 exquisite and botanically accurate watercolour records of Anglesey's flora, labelled in Latin, Welsh and English, benefitting from the works of 'Anglesey Linnaeus' Revd Hugh Davies (1739–1821) of Llandyfrydog. Massey and her sister Edith lived at Cornelyn, Llangoed, where she painted the plants collected by Edith, capturing botanically accurate reproductions of the roots, stems, leaves and flowers, often in their stages of budding, flowering and fruiting. Massey's style of painting plants in their natural habitat, *en plain air*, is indicated by the scarcity of pencil markings. She was also interested in the medicinal properties of the plants that she painted. The six-volume collection of paintings was bought at auction by Anglesey Borough Council, and is preserved at the Oriel Môn, Llangefni. It is a unique document of Anglesey's botanical diversity at that time and shows the agriculturally induced extinction of certain species, such as corncockle and purple spurge.

Living almost in the same house as Tunnicliffe in full view of the Cefni Estuary, with its extensive sandbanks exposed at low tide, is the well-known wildlife and landscape artist Philip Snow. He has contributed to more than eighty books and has produced prints, cards, calendars and reserve guides, and provides art workshops. His books include *Collins Field*

Above left: Autobiography of Kyffin Williams.

Above right: Oriel Môn's book that illustrates the exceptional paintings of selected Anglesey plants by Gwendolyn Massey.

Left: Philip Snow's book (2020) on the wildlife of Anglesey.

Notebook of British Birds, *River Birds* and *Birds by Behaviour Guides*, *River Birds* and *Birds of Mull and Iona*. He regularly featured in the *BBC Wildlife* magazine, as well as *RSPB Birds*, *Birdwatching* and *Cheshire Life*. He recently wrote and illustrated *Light & Flight – A Hebridean Wildlife & Landscape Sketchbook*, and *The Design & Origin of Birds*, reflecting his religious beliefs. He is widely exhibited, including in the Mall Galleries, Tryon Gallery and the Barbican, and is featured in the Royal Academy 'British Art'. *Tall Tales from an Estuary* is his fascinating account, as viewed from the eyes of an observant Howell the Heron, of the various avian visitors to the estuary and touches on changing migration and climate patterns and the detrimental human influence. His latest book is *Anglesey Naturewatch*, in which he illustrates parts of Anglesey and aspects of wildlife that inhabit each individual area. His work clearly continues the wildlife sensitivity of Tunnicliffe but with his own unique style.

TOURISM

Anglesey is the UK's most tourism-dependant local authority with agriculture-based income ranking second. It attracts more than 1.7 million tourists annually, and in 2018 tourism contributed more than £304 million to its economy. Anglesey is the least populated county in Wales, with a total of fewer than 70,000 residents, with the least population growth and an expected population contraction of 0.5 per cent by 2028 and 2.4 per cent by 2038. In 2017, only 26,200 residents were employed, and this explains why tourism is the prime source of the island's income. These numbers swell during the summer when the island's tourists visit and contribute significantly to the economy. Despite tourism's extremely important contribution to the island's economy, its development has had significant implications for nature conservation in Anglesey.

In addition to the host of geological, historic and wildlife attractions that generate work for residents, numerous other attractions have been initiated to take advantage of tourist-based income. Accommodation, in terms of hotels, guest houses, caravan and camping sites, together with restaurant facilities provide the obvious sources of work and provide work for a host of supportive service activities. Top attractions include South Stack Lighthouse, Newborough Forest, Warren and Llanddwyn Island, Beaumaris Castle and Gaol, Plas Cadnant Hidden Gardens, RSPB South Stack Reserve, Holyhead Breakwater Park, and Plas Newydd National Trust house and gardens while at the same time causing a concern of inflating house prices beyond the reach of young local families.

MUSEUMS

Several museums exist on Anglesey, most of which are the result of dedication by volunteers to provide a repository for artifacts related to various aspects of the island's history. In addition to providing work for support staff they are superb resource for researchers and are popular tourist attractions in the summer.

ORIEL MÔN

Oriel Ynys Môn at Llangefni was opened by the Queen in 1991 and has established itself as one of Wales' leading art venues. In addition to a rich permanent display of archaeological artifacts from the Bronze Age to the 1800s, there is a display of aspects of the *Royal Charter* ship disaster together with a realistic impression of the ship's deck at that time. The highlight of the museum is its art displays. The Oriel Kyffin Williams, opened in 2013 by Lady Anglesey at a cost of £1.5m, displays selected works by one of Anglesey's most respected artists. The collected works of the other famous artist Charles Tunnicliffe are also kept and displayed, as are the botanical works of Gwendolen Massey. The Oriel serves as a focal point for local people to observe Anglesey's archaeological and historic finds that escape being sent to the National Museum of Wales.

COPPER KINGDOM

The Amlwch Heritage Trust have established a gem of a museum, the Copper Kingdom museum, in the old copper bins on Amlwch harbour where ore is held before transferring to the ships for transport. The museum exhibits many interesting artifacts spanning the Bronze, Roman and Victorian ages. The tour takes the visitor past many unique exhibits and information boards that complement the Porth Amlwch Heritage Trail.

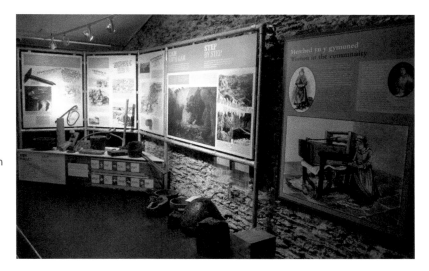

One of the numerous galleries displaying artifacts from Parys Mountain copper mine at the Copper Kingdom museum on Amlwch harbour.

STONE SCIENCE

Dave Wilson and his wife operate one of the largest collections of fossils in Wales at their two-storey Stone Science museum at Llanddyfnan, near Pentraeth. The fossils range from dinosaurs to microfossils, span the last 640 million years of Earth's history and are displayed in order of geological time. A specimen of the rare Anglesey lead sulphate mineral Anglesite was discovered in the Parys Mountain copper mine by William Withering in 1783.

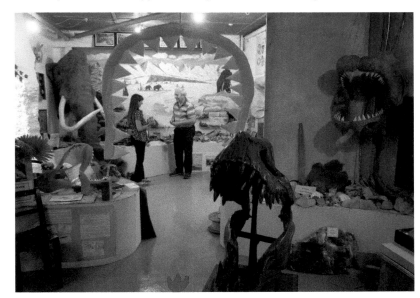

Dioramas in the Stone Science Museum at Pentraeth.

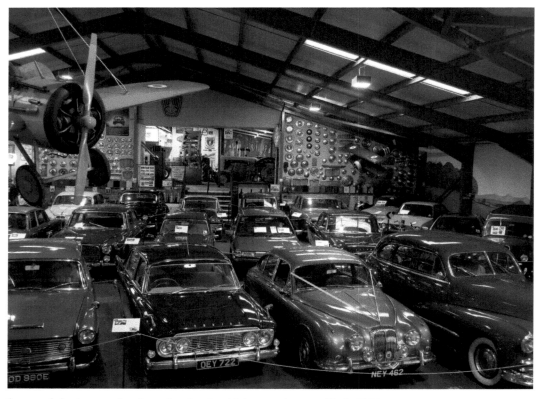

Some of the immaculately maintained vehicles on show at Tacla Taid.

TACLA TAID MOTOR MUSEUM

This transport and agriculture museum is the largest of its kind in Wales and has well-kept displays of over 100 classic cars; motorbikes; commercial, military and farm vehicles; and static engines. Run by enthusiast Arfon Williams, the museum is the product of his training as a mechanic and collector of vehicles. His dedication to restoring and rebuilding transport relics of the past, especially from the 1920s to 1960s, to a near-new condition can confidently be termed a healthy obsession. Tacla Taid was the natural outlet of Arfon's collection of restored vehicles and opened in 2001 near Newborough.

MARITIME MUSEUM

This officially opened in St Elfod's Church in March 1986, following maritime exhibitions in Holyhead in 1983 and 1984. It moved to the renovated Lifeboat House, the oldest in Wales (*c.* 1858), at Newry Beach where it was reopened in 1998. The museum is operated by trustees and is a treasure of memorabilia of Holyhead and Anglesey's association with maritime activities. An adjacent Second World War air-raid shelter houses a permanent exhibition of Holyhead's wartime experiences.

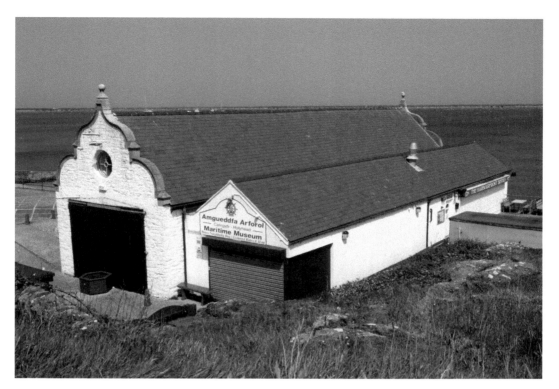

Holyhead's Maritime Museum.

BEAUMARIS GAOL AND COURTHOUSE MUSEUM

The Beaumaris Gaol and Courthouse Museum was opened in 1974, although the building had not been a prison since 1878 when it became a police station. It was built in 1829 and expanded to hold thirty prisoners in 1867. Two hangings took place before its closure in 1878. Probably the first prison on Anglesey was that at Beaumaris Castle, as thirteen Protestant-like Lollards are recorded as being imprisoned there in 1396. The courthouse in Beaumaris was the oldest in Wales and served justice for the island between 1614 and 1971, but as the proceedings were in English, the Welsh defendants were at a distinct disadvantage. George II passed a law that sent even minor offenders to the Americas and several were sent from Anglesey until the American Revolution in 1775.

ANGLESEY SEA ZOO AND BUTTERFLY PALACE

The Anglesey Sea Zoo, Sŵ Môr Môn, was opened in 1983 and is a unique aquarium and independent research and marine education centre outside the village of Brynsiencyn. It is the largest aquarium in Wales and displays over 150 native species including octopus, lobsters, seahorses, conger eels and jellyfish. It is involved in conservation projects that include a lobster hatchery, seahorse nursery and crawfish breeding. In 2016 the zoo aided the only known olive ridley turtle ever to reach British waters from the Caribbean. She was

Stained-glass window at the Sea Zoo near Brynsiencyn.

rehabilitated and returned to her home in 2017. Tropical butterflies are on display at the Butterfly House at Pili Palas Nature World near Menai Bridge.

Smaller museums with focussed attractions include the Pritchard Jones Institute in Newborough containing a wealth of information about Newborough and its history with a display of intricate marram basketry made by the craftswomen of the village. Cemaes Heritage Centre displays a fascinating collection of memorabilia relating to the work activities of Cemaes. The Swtan Heritage Museum preserves a mid-eighteenth-century homestead. The Menai Heritage Thomas Telford Centre contains information and memorabilia about Thomas Telford's activities on the island.

ACKNOWLEDGEMENTS

My gratitude goes to the following kind acquaintances who unreservedly offered their assistance to me during the compilation of this book. Elfed Jones (Oriel Cemaes), Carys Davies (Cemaes Heritage Centre), Ian Jones (Oriel Llangefni), David and Elspeth Wagstaff (Pandy Parc and Copper Kingdom Museum artifacts), Mrs Sylvia Speers (Pandy Llywenan), Barry Hillier (Holyhead Maritime Museum), David Farrell (Bryn Dyfrydog Welsh Black cattle), PC Byron (Rhuthun Police Force), Richard Williams (author of *Melinau Môn*), Dave Wilson (Stone Science), Twm Elias (author of *Drovers of Wales*), Keith Cole (The Soap Shop, Beaumaris), Phillip Snow (Malltraeth artist and author), Sonjia Bradley (red squirrel photograph), Ruth Jennings (Pencae Veg., Llanfaethlu), Dr Margaret Wood (Geomôn discussions), Dr W. Morgan (Fron gorse mill), Mr A. Windsor of (alfie@hmsconwy.org), Paul and Chris Rogers (Shorelands, Malltraeth), Rob of Llanfairpwll Distillery, Sue Loose (investigative companion and butterfly photograph) and not least, my late wife Milika for her unquestioning support.

The following references and sites proved highly informative:

Coflein (www.coflein.gov.uk)
Kovach, W., *Anglesey in 50 Buildings* (Amberley Publishing)
Welsh Mills Society (welshmills.org)
https://www.anglesey-history.co.uk
http://www.nationalarchives.gov.uk/doc/open-government-licence/version/3/ for the RAF Griffin helicopter photograph opportunity.
Photochrom Print Collection, Library of Congress Catalogue: http://lccn.loc.gov/2001703565

ABOUT THE AUTHOR

Geraint Wyn Hughes is a micropalaeontologist, natural historian and holds PhD, DSc, MSc and BSc (Hons) degrees from the University of Wales, Aberystwyth. He is Professor at King Fahd University of Petroleum and Minerals, lectures at the universities of Birmingham and Urbino and is an Associate Scientist at the Natural History Museum. His interest in past worlds extends from Carboniferous foraminifera to recent history and he is fascinated by the richness of all aspects of geology, prehistory, history, geomorphology and wildlife of Anglesey, this island having been a favourite family destination since his childhood.